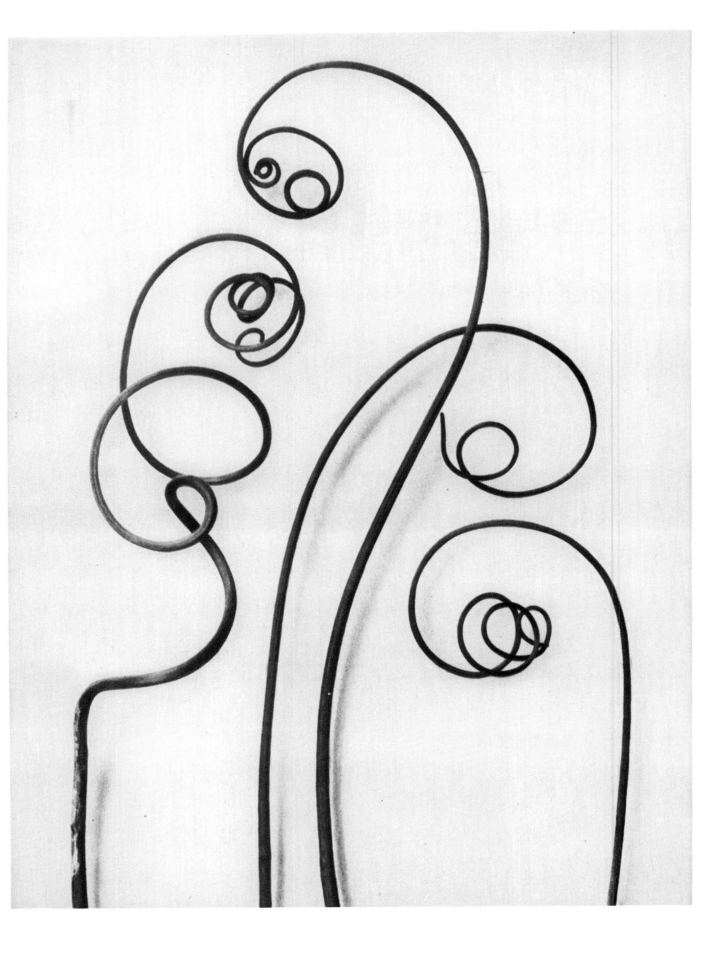

NATURAL ART FORMS

120 CLASSIC PHOTOGRAPHS

KARL BLOSSFELDT

DOVER PUBLICATIONS, INC.
Mineola, New York

Copyright

Copyright © 1998 by Dover Publications, Inc.
All rights reserved under Pan American and International Copyright Conventions.

Published in Canada by General Publishing Company, Ltd., 30 Lesmill Road, Don Mills, Toronto, Ontario.

Bibliographical Note

This Dover edition, first published in 1998, is an unabridged republication of the work first published by E. Weyhe, New York, in 1932 under the title *Art Forms in Nature, Second Series: Examples from the Plant World Photographed Direct from Nature.* (The original German edition was first published by Verlag für Kunstwissenschaft GmbH, Berlin, in 1932 under the title *Wundergarten der Natur, Neue Folge: Urformen der Kunst.*) The descriptions of the plates, which appeared in the frontmatter of the original edition, have been corrected slightly and appear as captions to the plates in the present edition. The new Publisher's Note was prepared specially for the Dover edition.

DOVER *Pictorial Archive* SERIES

Library of Congress Cataloging-in-Publication Data

Blossfeldt, Karl, 1865–
 [Wundergarten der Natur. English]
 Natural art forms : 120 classic photographs / Karl Blossfeldt.
 p. cm.
 "This Dover edition . . . is an unabridged republication of the work first published by E. Wayhe, New York, in 1932 under the title 'Art forms in nature, second series: examples from the plant world photographed direct from nature.' The original German edition was first published by Verlag für Kunstwissenschaft GmbH, Berlin, in 1932 under the title 'Wundergarten der Natur, Neue Folge: Urformen der Kunst' — T.p. verso.
 ISBN 0-486-40003-4 (pbk.)
 1. Photography of plants. 2. Decoration and ornament—Plant forms. I. Title.
TR724.B56513 1998
779'.34—dc21 97-53262
 CIP

Manufactured in the United States of America
Dover Publications, Inc., 31 East 2nd Street, Mineola, N.Y. 11501

PUBLISHER'S NOTE

A teacher and a sculptor for much of his working life, Karl Blossfeldt (1865–1932) did not achieve recognition as a photographer until his very last years. When his first series of photographs—*Urformen der Kunst* ("Archetypes of Art")—was published in 1928, Blossfeldt was already sixty-three; he died soon after the 1932 publication of the second series, *Wundergarten der Natur* ("Nature's Magic Garden").* During those four years, however, he came to be known both in Germany and abroad as an exemplar of the style that was loosely called "Neue Sachlichkeit," that is, New Realism or Objectivism.

This label was first applied to painters such as George Grosz and Otto Dix, whose work stood in stark contrast to the impressionistic and the expressionistic styles so prevalent before the First World War. Whereas the Impressionists believed that art should record visual impressions left by actual experience, and the Expressionists strove to reveal an inner, emotional reality, the New Realists strove to objectively catalog everyday life. Their focus was broad and unsparing, embracing all aspects of existence, no matter how sordid or mundane.

For those whose subject was mankind, the result was frequently a bleak depiction of human suffering, vice, and folly; Karl Blossfeldt, however, turned his eye to the natural world, creating studies of plant forms, both whole and in part. His "objectivism," in fact, was an aesthetic choice brought about by necessity rather than philosophy. He had taken up photography to assist him in his work as a professor for modeling plants at a school for the fine and applied arts, and his methods were largely governed by his needs: his use of direct lighting crisply defined the form of his subject; a sharp focus brought out its texture and detail; and a magnification of up to twenty-five times the actual size made apparent much that was hidden from the naked eye. It was only later that the photographer came to see his images as artistic objects unto themselves.

*The two volumes were first published in America under the series title *Art Forms in Nature: Examples from the Plant World Photographed Direct from Nature* (first series: 1929; second series: 1932). The first series was reprinted in 1985 by Dover Publications, Inc., as *Art Forms in the Plant World* (24990-5).

Far from being cold, clinical studies, Blossfeldt's austerely beautiful prints reveal designs in nature as marvelous as anything man might create. Separated from their natural settings, his leaves and twigs and seed casings seem to resemble nothing so much as Gothic ornament, or wrought ironwork, or elements from Classical architecture. The similarity of his segments of plants to man-made forms suggests not only that nature has always been a model for art (intentionally or no), but that structure and beauty are by no means exclusive to either.

In the captions of the present edition, several of the plant names have been corrected or altered to more familiar forms. The amounts of magnification or reduction given correspond to the images in the present edition.

FOREWORD

The universal recognition given to my work "Art Forms in Nature" has encouraged me to publish a further collection of studies of plant life. It would be useless for me here to attach any especial meaning to the photograph-studies forming this collection. Verbose explanations would only detract from the deep impression created by them. The unanimity of critics of all countries in their favourable comment on the first collection, and the letters received from art and lay circles, indicate to me how healthily alive the appreciation of beauty still remains. Every sound expansion in the realm of art needs stimulation. New strength and stimulus for its healthy development can only be derived from Nature. And it is with this end in view that I have published this second volume—to arouse the Nature-sense, to demonstrate the wealth of beauty in Nature, to stimulate observation of our own plant world.

The plant may be described as an architectural structure, shaped and designed ornamentally and objectively. Compelled in its fight for existence to build in a purposeful manner, it constructs the necessary and practical units for its advancement, governed by the laws familiar to every architect, and combines practicability and expediency in the highest form of art. Not only, then, in the world of art, but equally in the realm of science, Nature is our best teacher.

KARL BLOSSFELDT

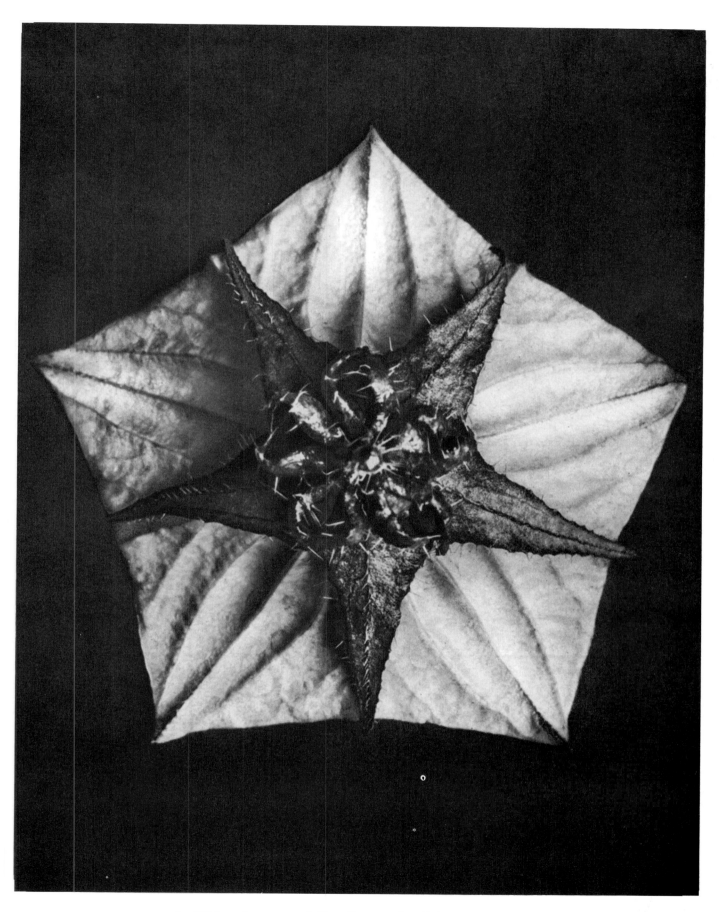

1. *Michauxia campanuloides.* Campanula. Enlarged 4.15 times.

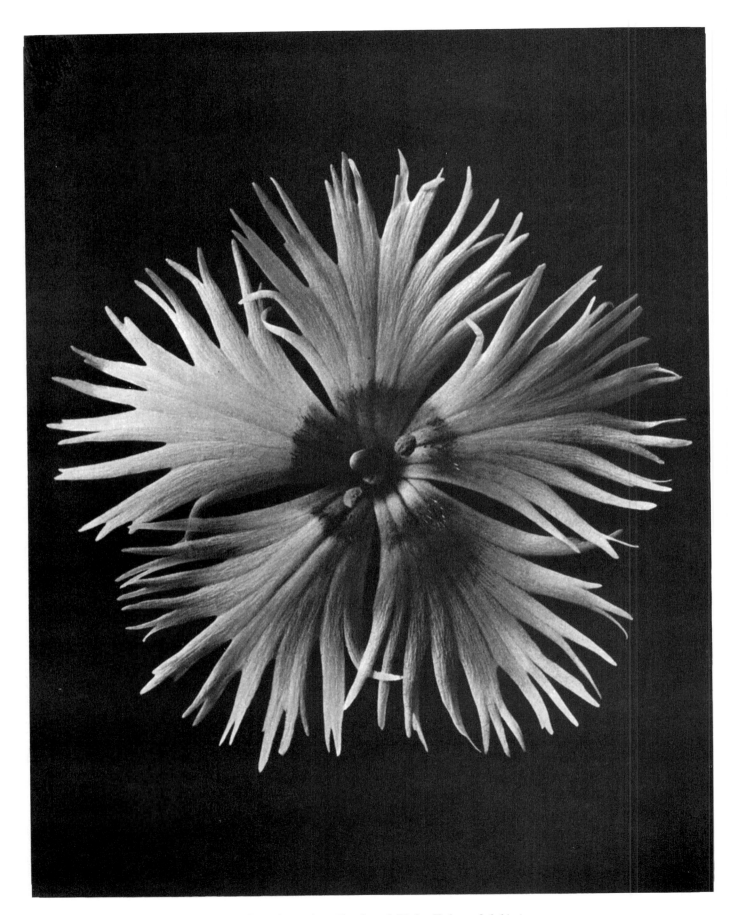

2. *Dianthus plumarius.* Feathered Pink. Enlarged 6.64 times.

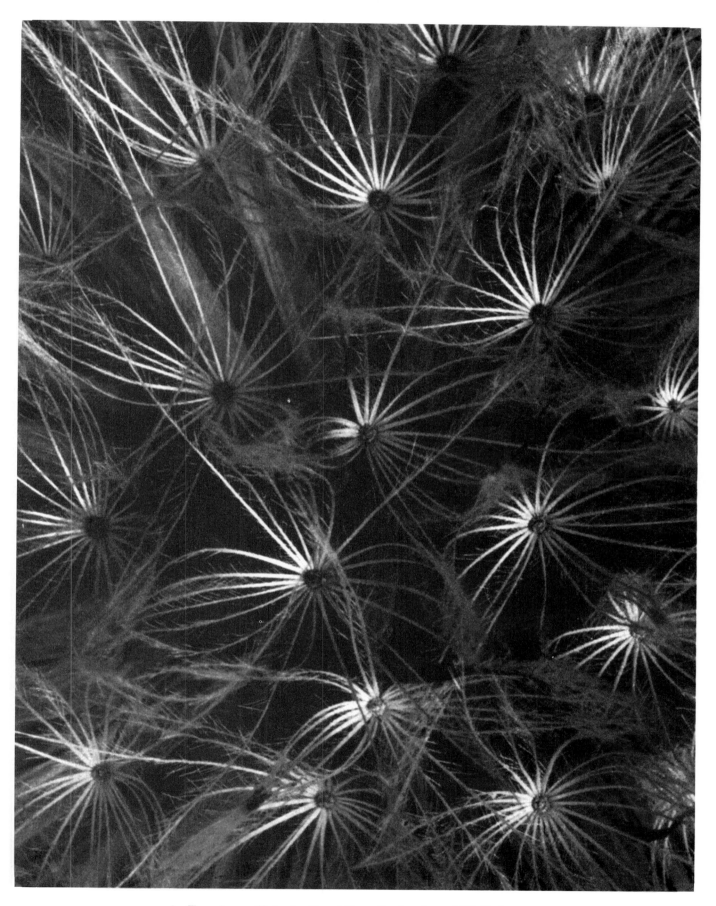

3. *Taraxicum officinale.* Dandelion. Seed, enlarged 12.45 times.

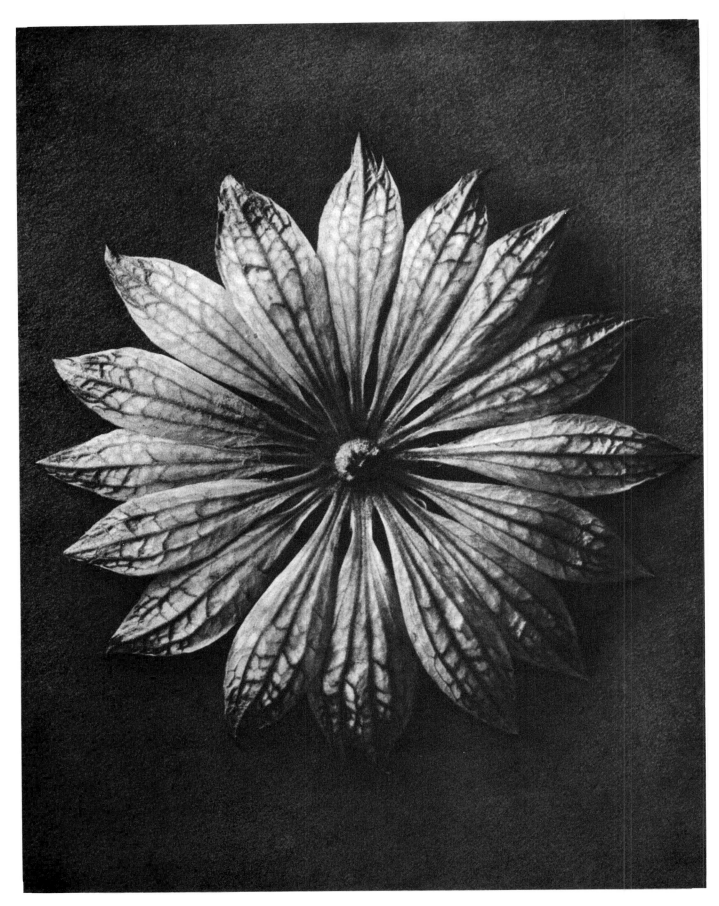

4. *Astrantia major.* Masterwort. Enlarged 8.3 times.

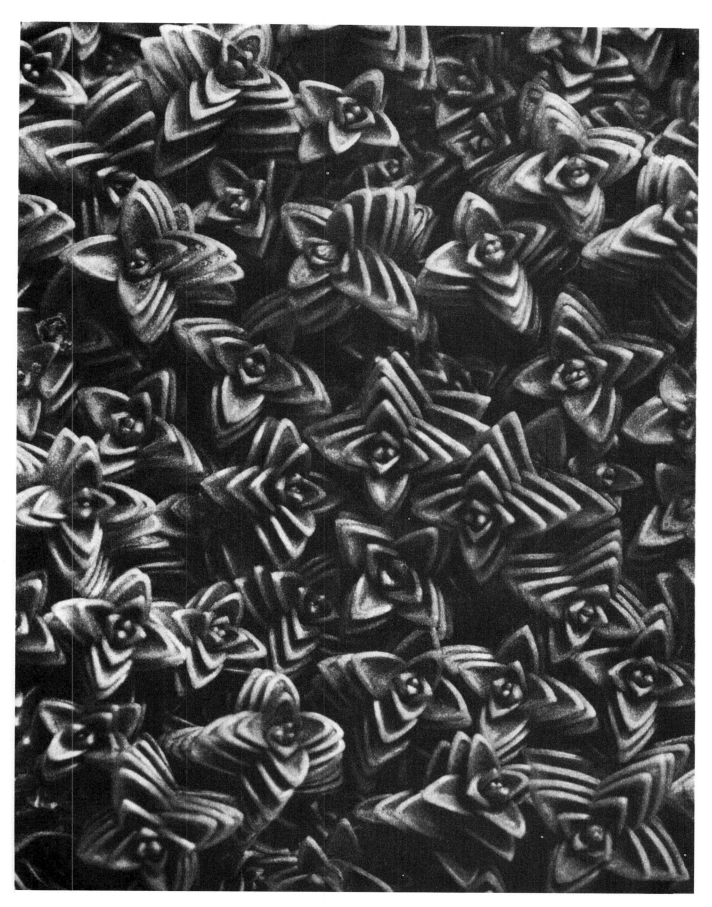

5. *Arenaria tetraquetra*. Sandwort. Enlarged 8.3 times.

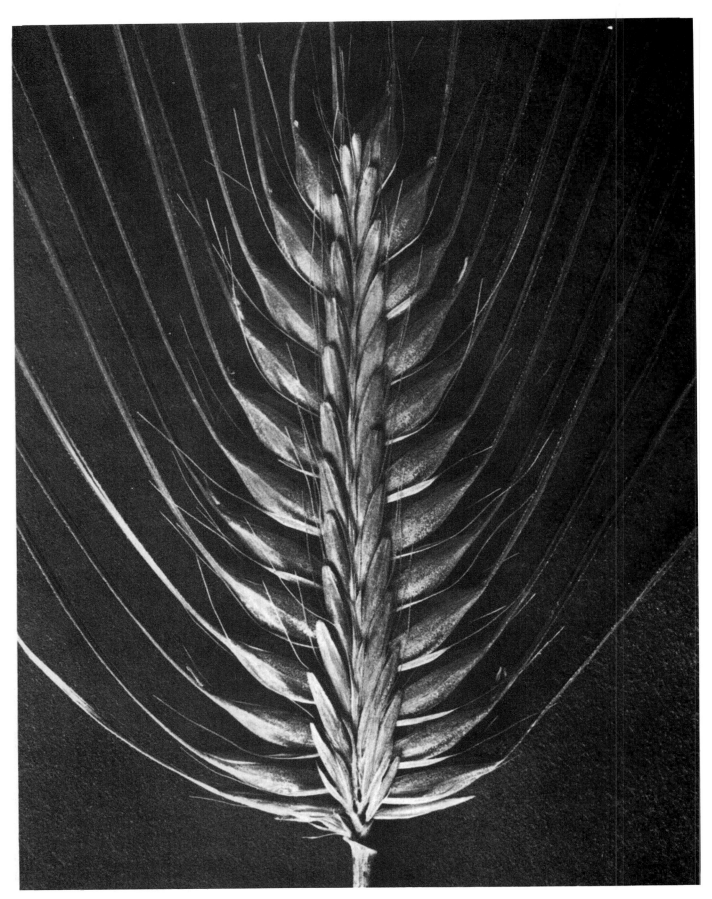

6. *Hordeum distichum.* Barley. Enlarged 3.32 times.

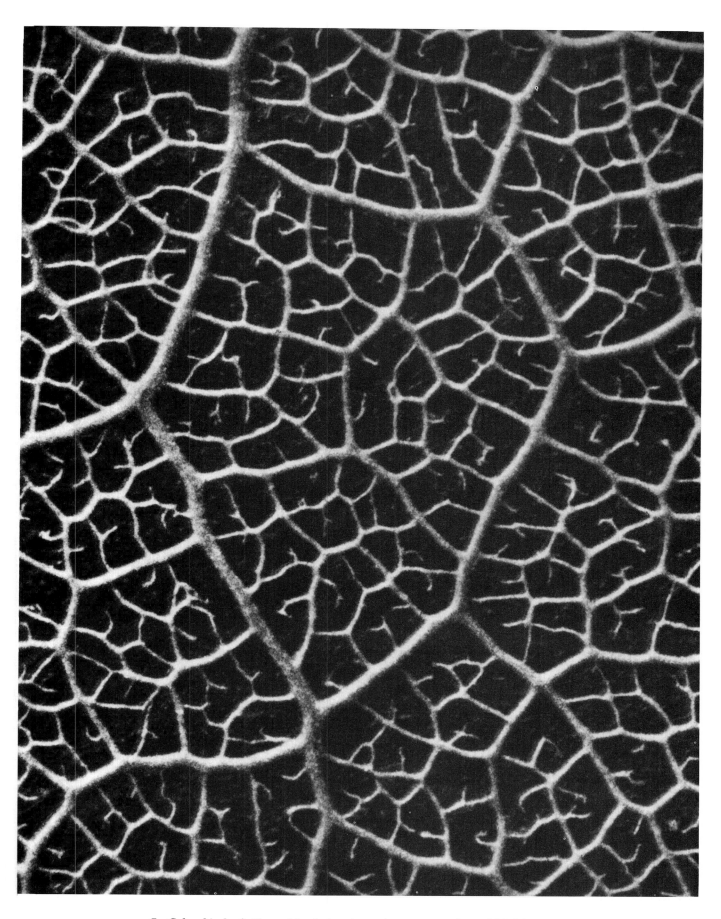

7. *Columbia leaf.* Part of leaf showing vein system, enlarged 37.35 times.

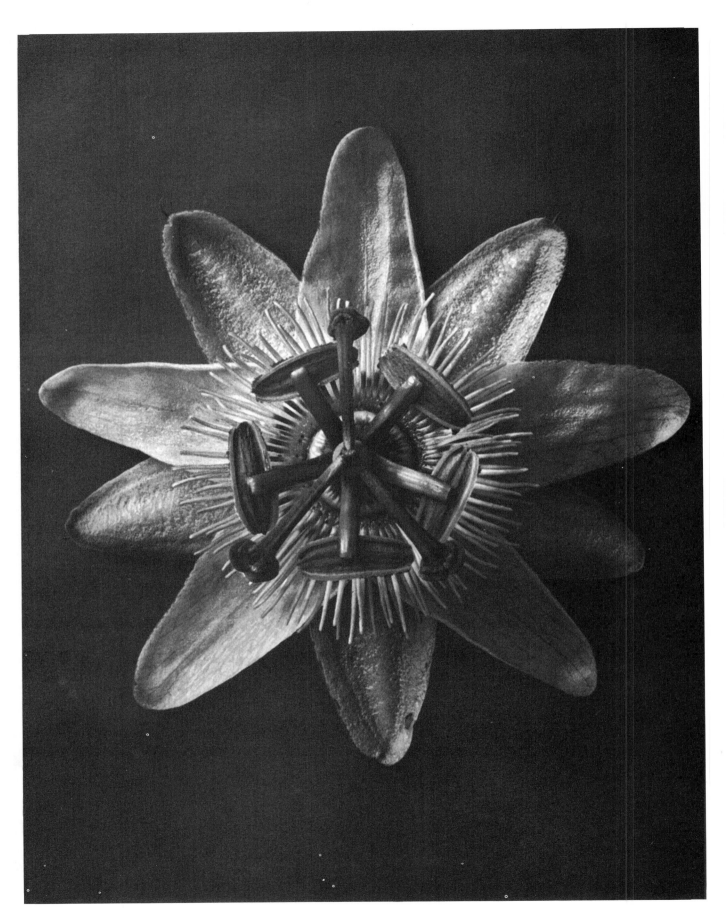

8. *Passiflora.* Passion Flower. Enlarged 3.32 times.

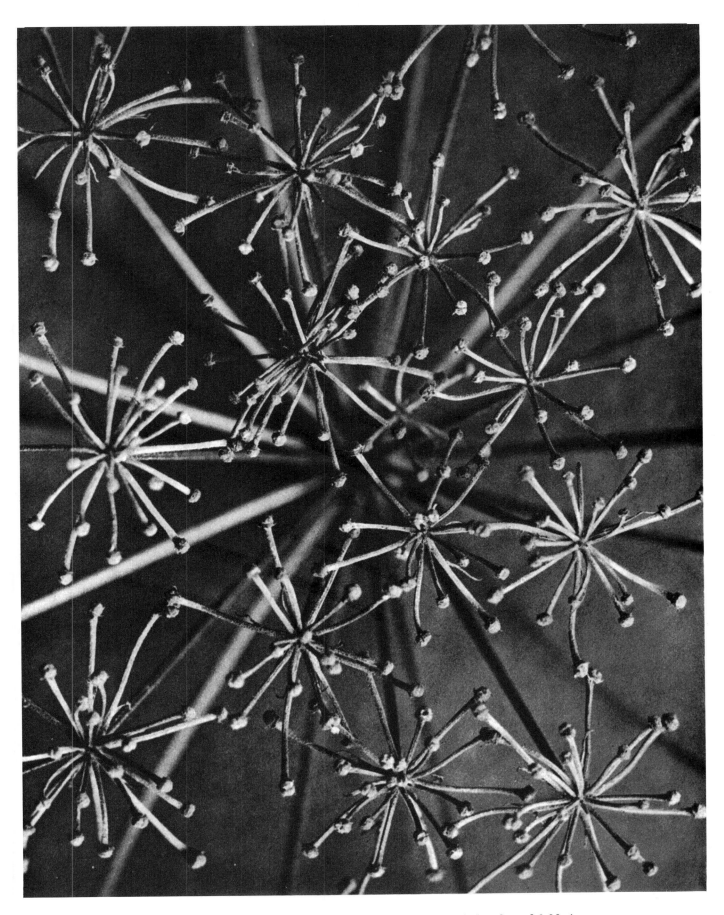

9. *Laserpitum siler.* Mountain Laserwort. Part of fruit-umbel, enlarged 3.32 times.

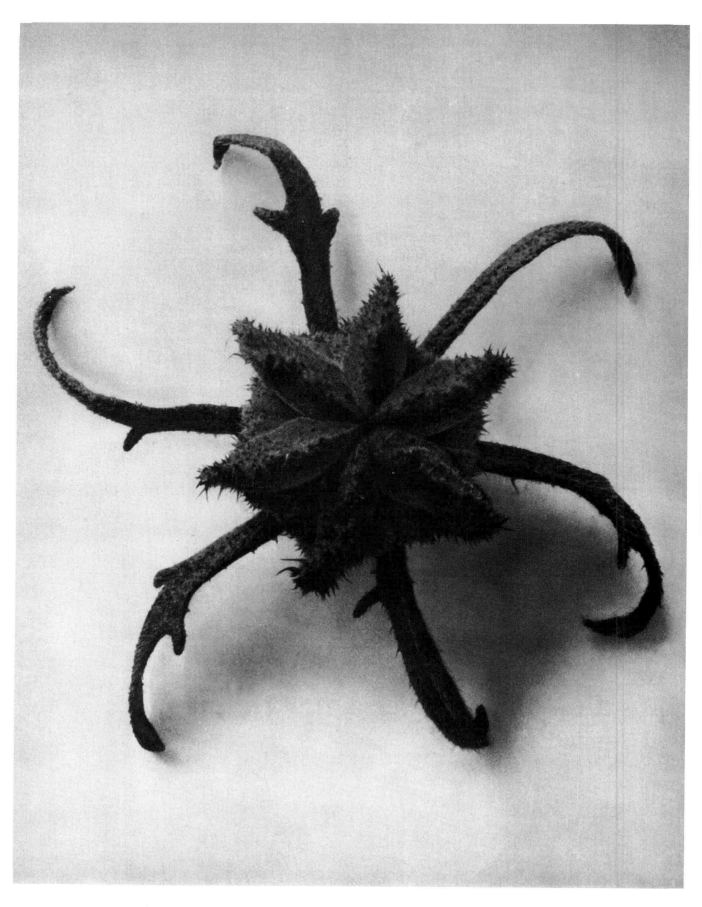

10. *Cajophora lateritia (Loasaceae)*. Chili Nettle. Flower-bud, enlarged 12.45 times.

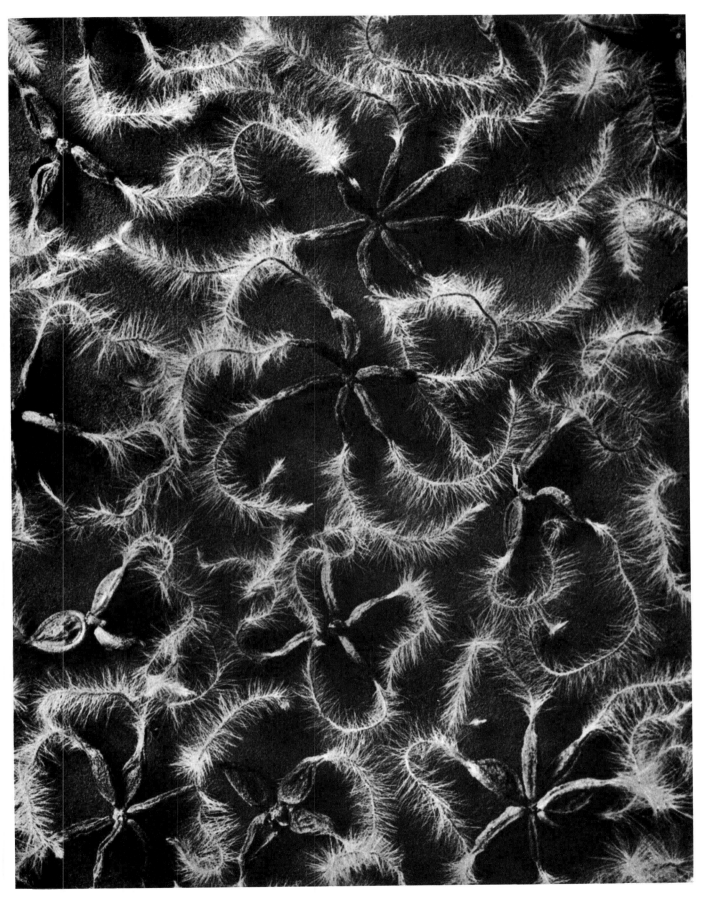

11. *Clematis recta.* Clematis. Seed, enlarged 3.32 times.

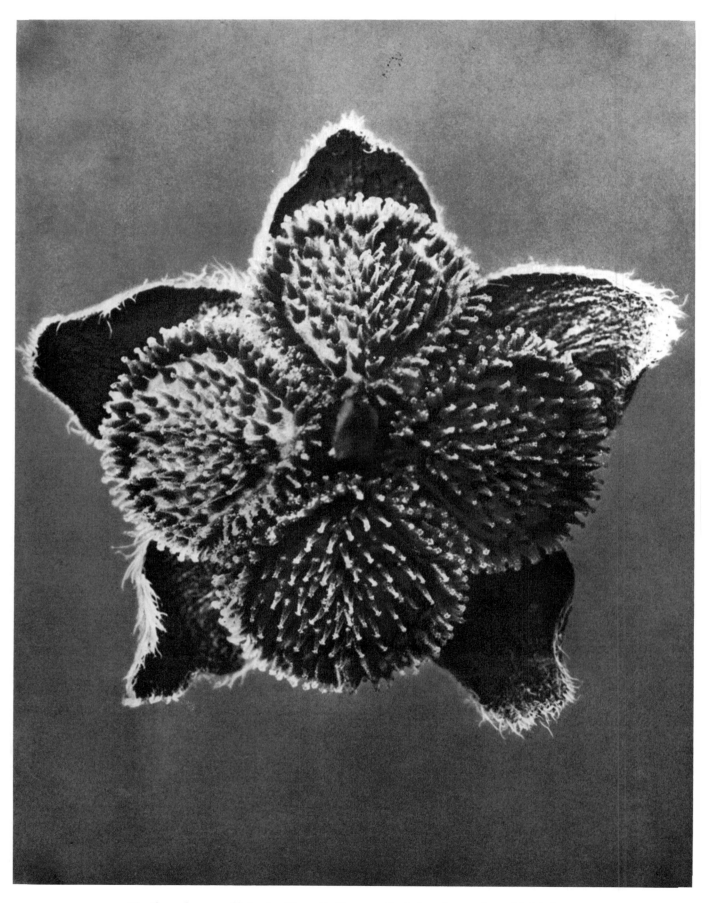

12. *Cynoglossum officinale.* Hound's Tongue. Fruit in calyx, enlarged 9.96 times.

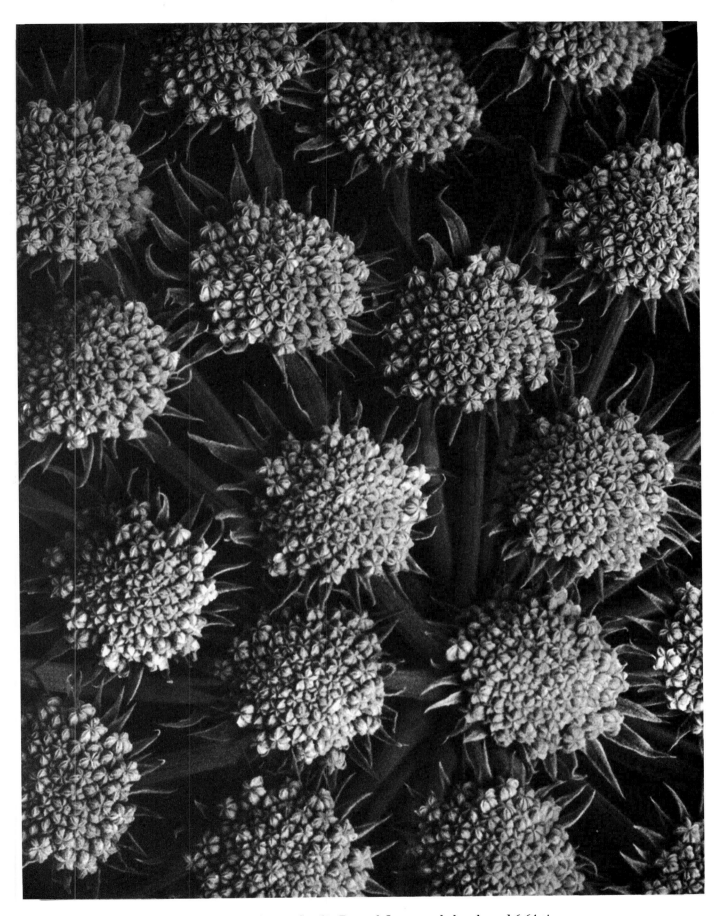

13. *Seseli gummiferum*. Seseli. Part of flower-umbel, enlarged 6.64 times.

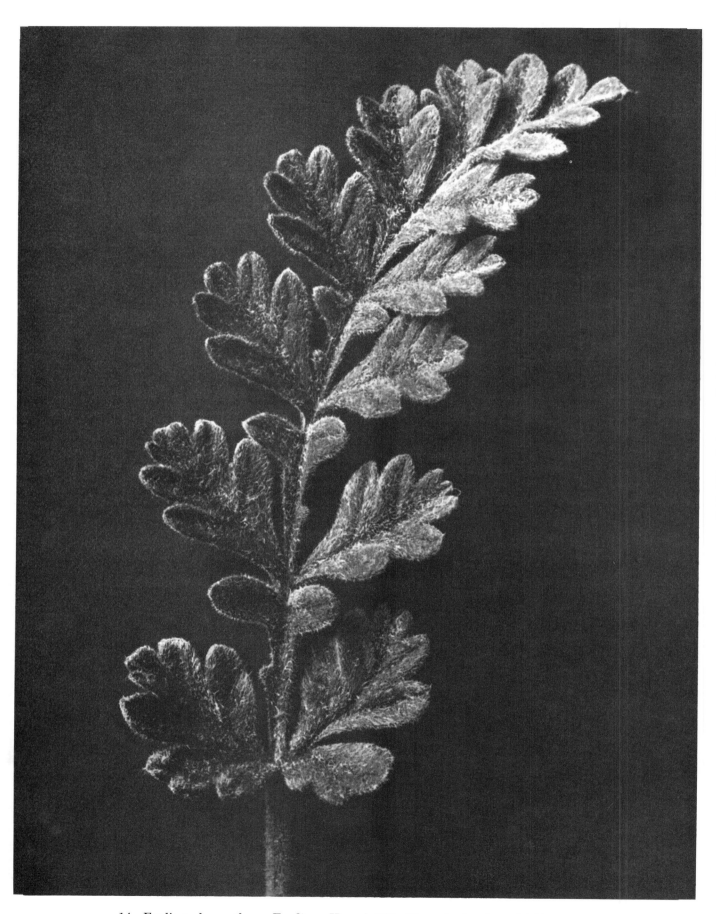

14. *Erodium chrysanthum*. Erodium, Heron's Bill. Young leaf, enlarged 4.98 times.

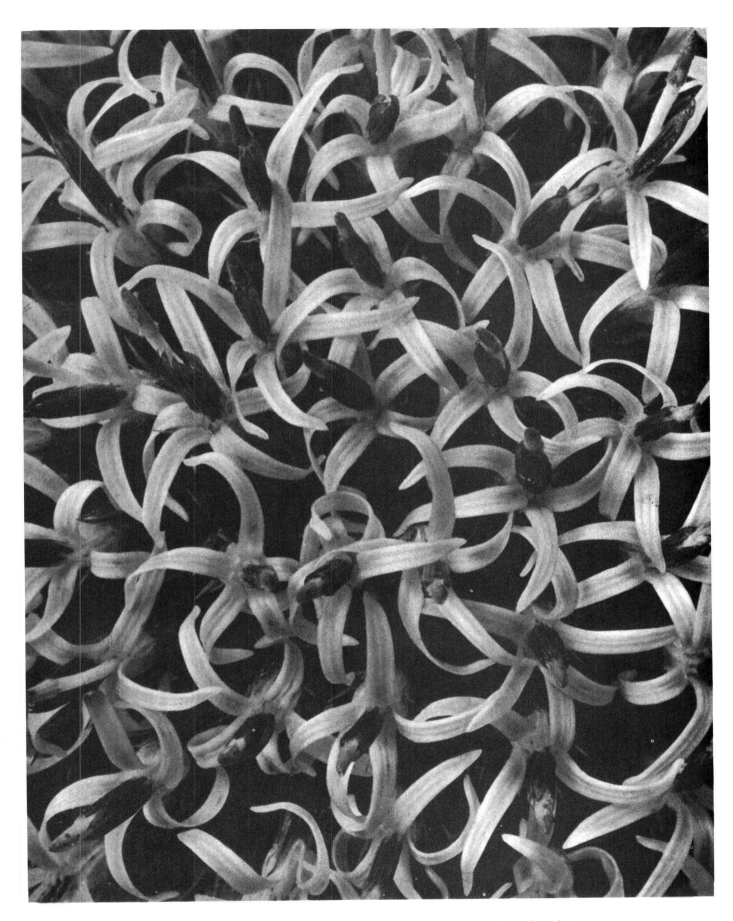

15. *Echinops sphaerocephalus.* Globe Thistle. Part of flower, enlarged 9.96 times.

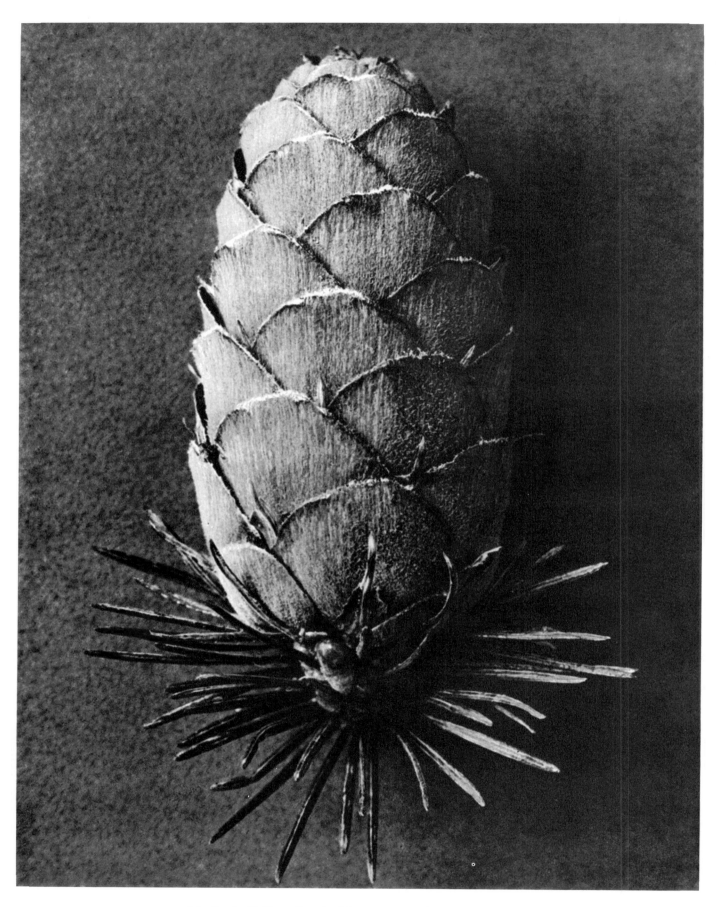

16. *Larix dicidua*. Larch. Young cone, enlarged 5.81 times.

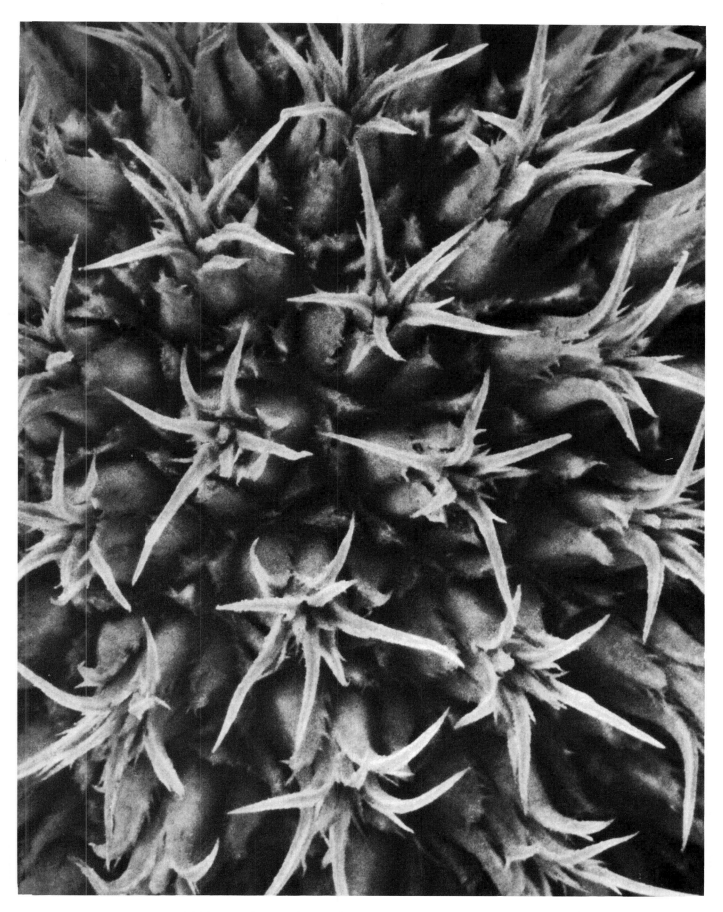

17. *Echinops sphaerocephalus.* Globe Thistle. Seed, enlarged 16.6 times.

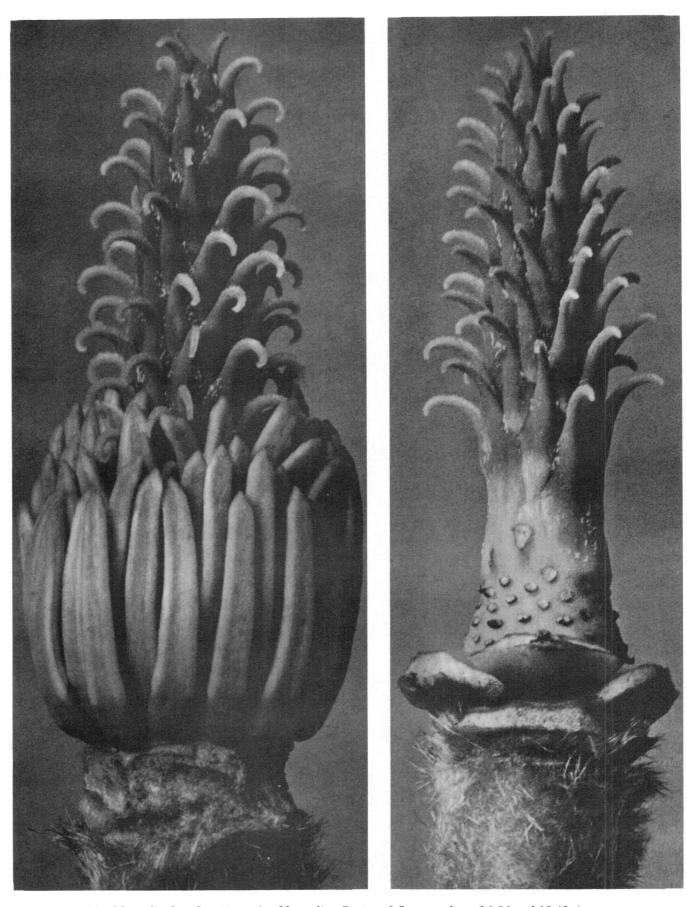

18. *Magnolia denudata × precia*. Magnolia. Centre of flower, enlarged 9.96 and 12.45 times.

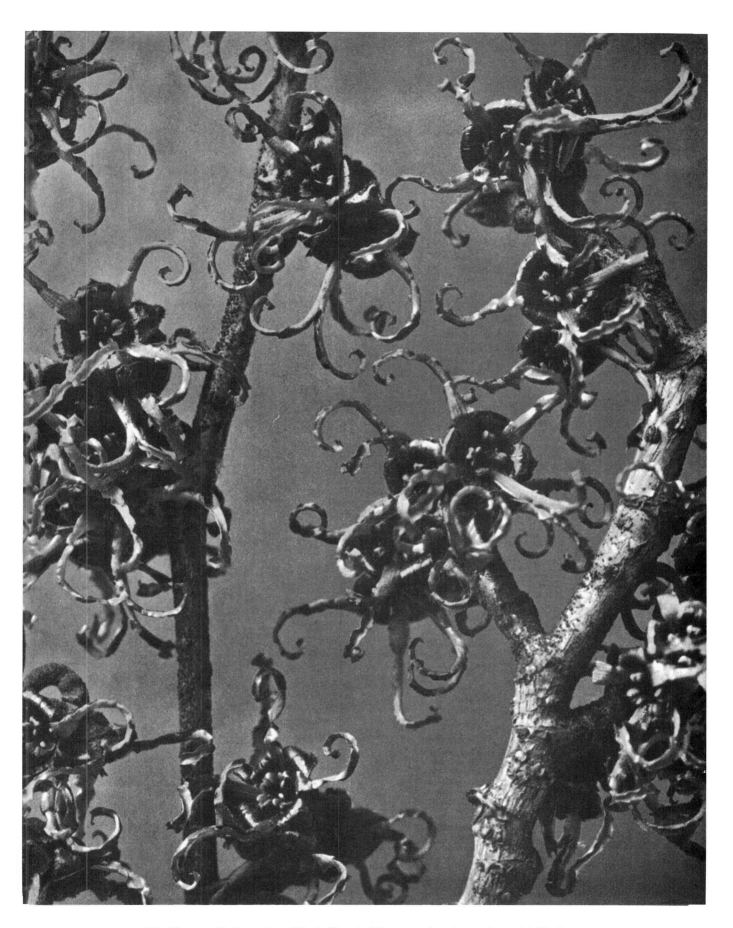

19. *Hamamelis japonica.* Witch Hazel. Flower peduncles, enlarged 4.98 times.

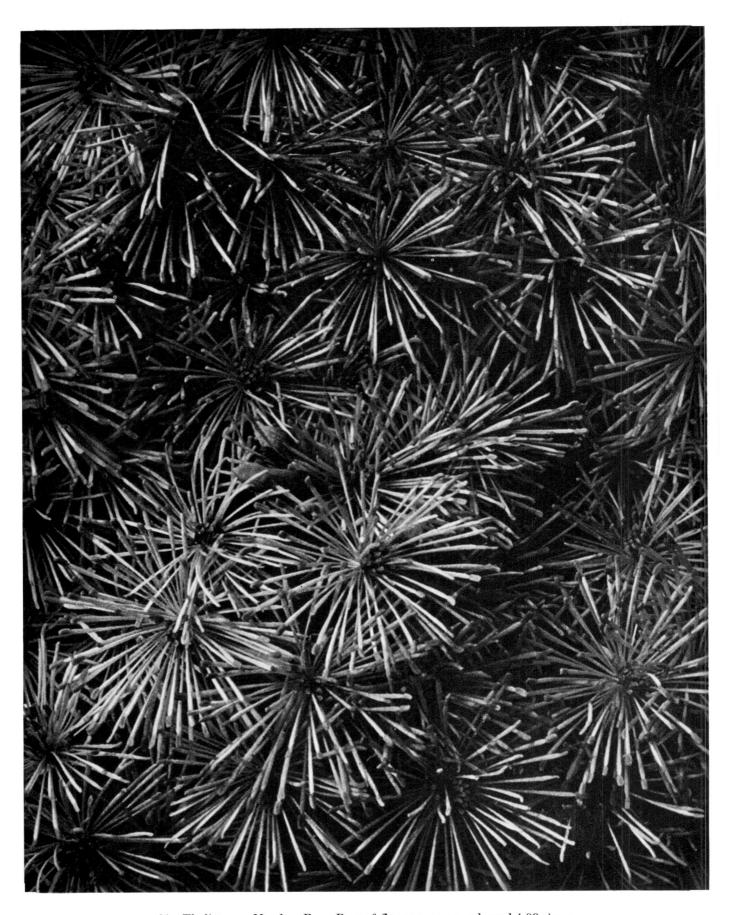

20. *Thalictrum*. Meadow Rue. Part of flower raceme, enlarged 4.98 times.

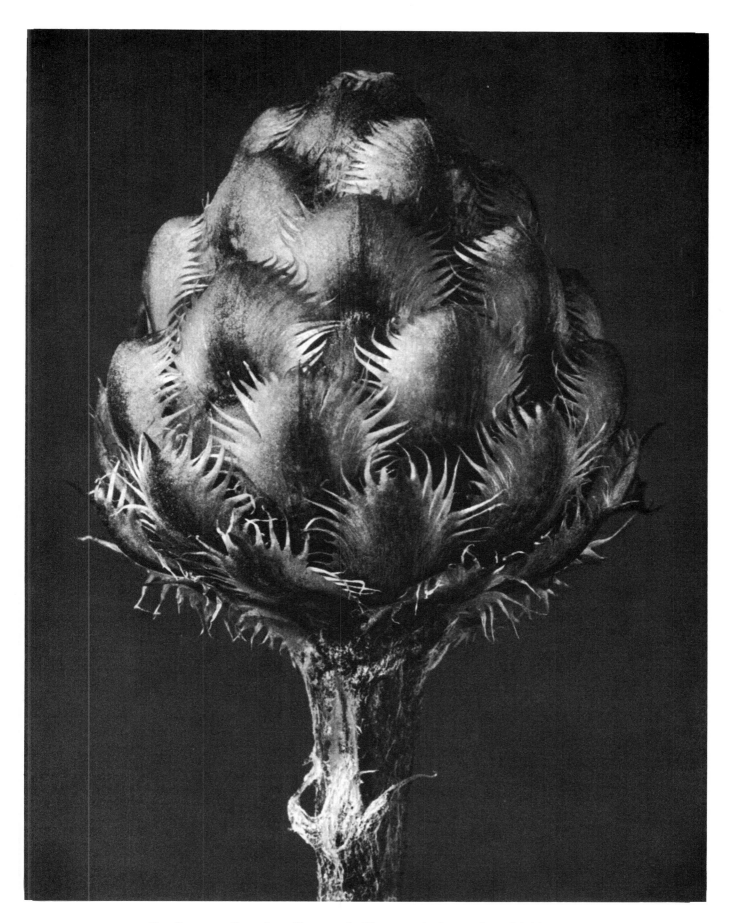

21. *Centaurea Grecesina*. Knapweed. Flower capitulum, enlarged 9.96 times.

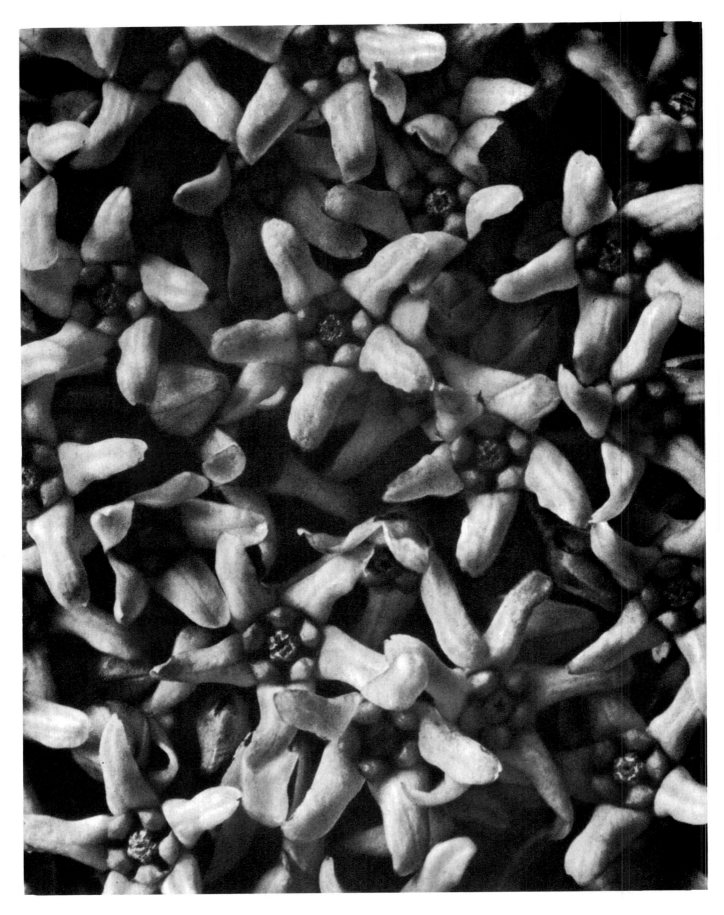

22. *Vincetoxicum album.* Swallow-wort. Flower-umbel, enlarged 8.3 times.

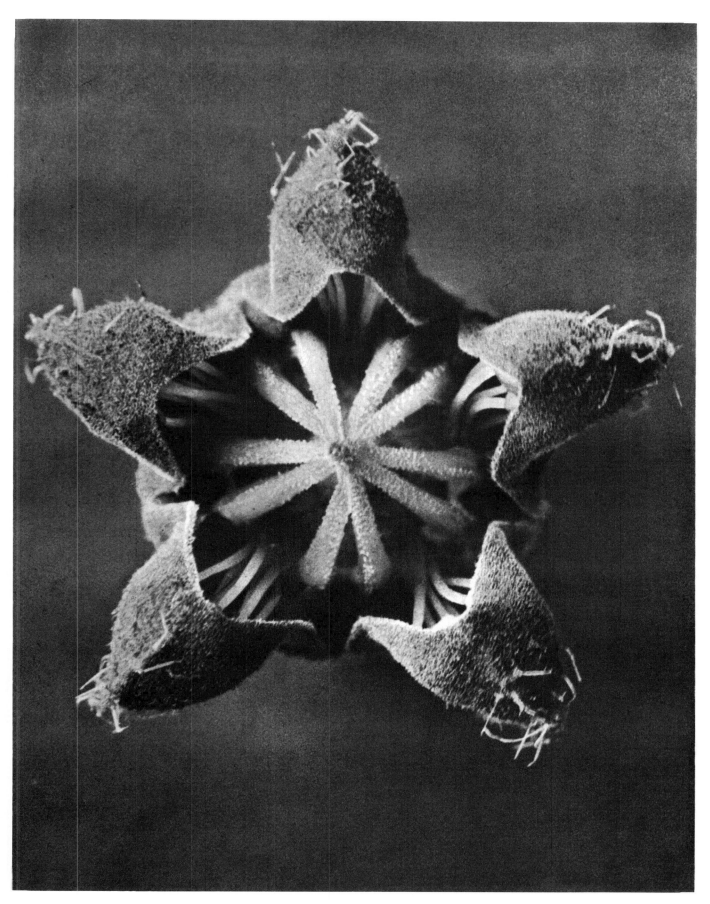

23. *Cajophora lateritia (Loasaceae)*. Chili Nettle. Flower-bud bursting open, enlarged 12.45 times.

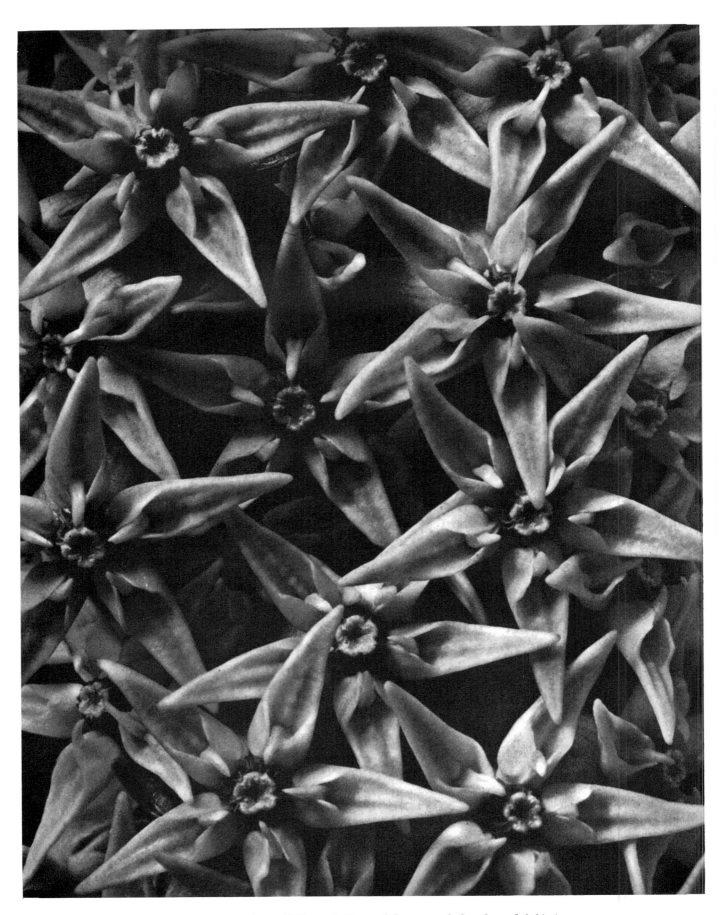

24. *Asclepias speciosa*. Milkweed. Part of flower-umbel, enlarged 6.64 times.

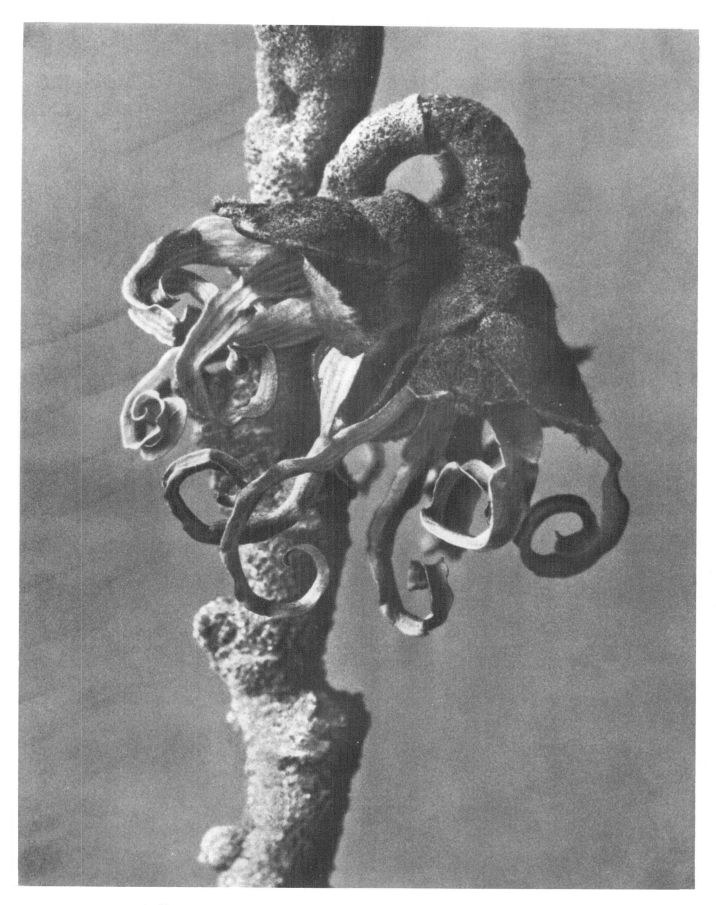

25. *Hamamelis japonica*. Witch Hazel. Flower peduncle, enlarged 12.45 times.

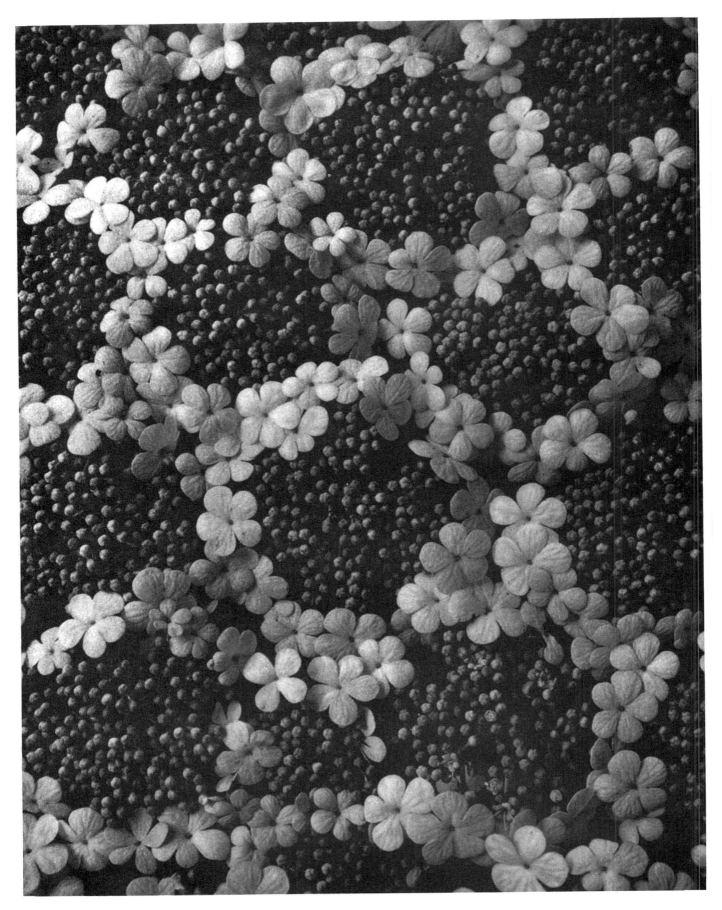

26. *Viburnum opulus.* Guelder Rose. Cymes, enlarged 2.49 times.

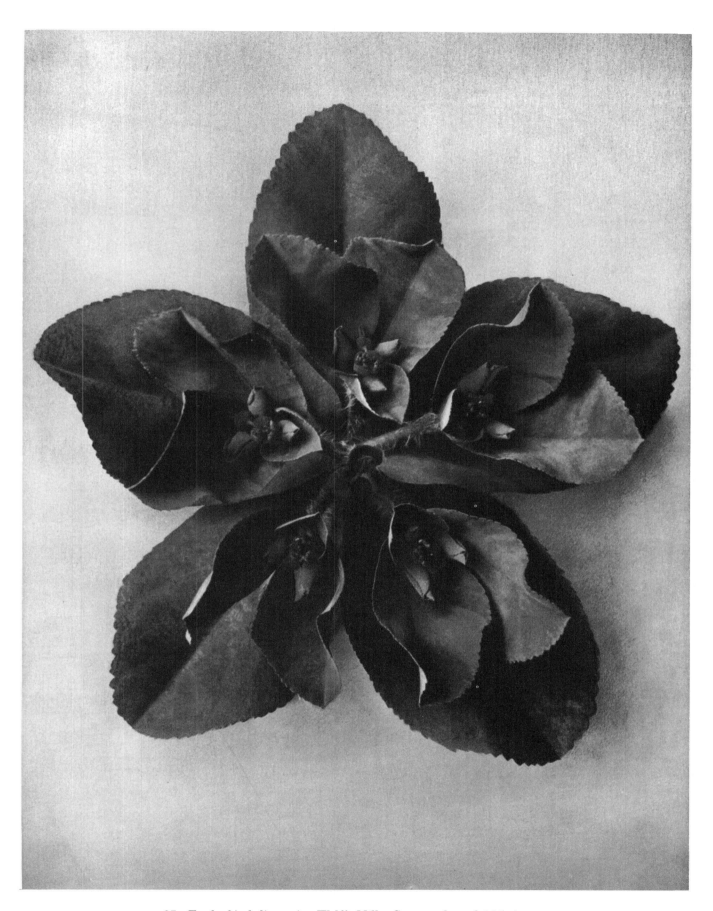

27. *Euphorbia helioscopia.* Wolf's Milk. Cyme, enlarged 4.15 times.

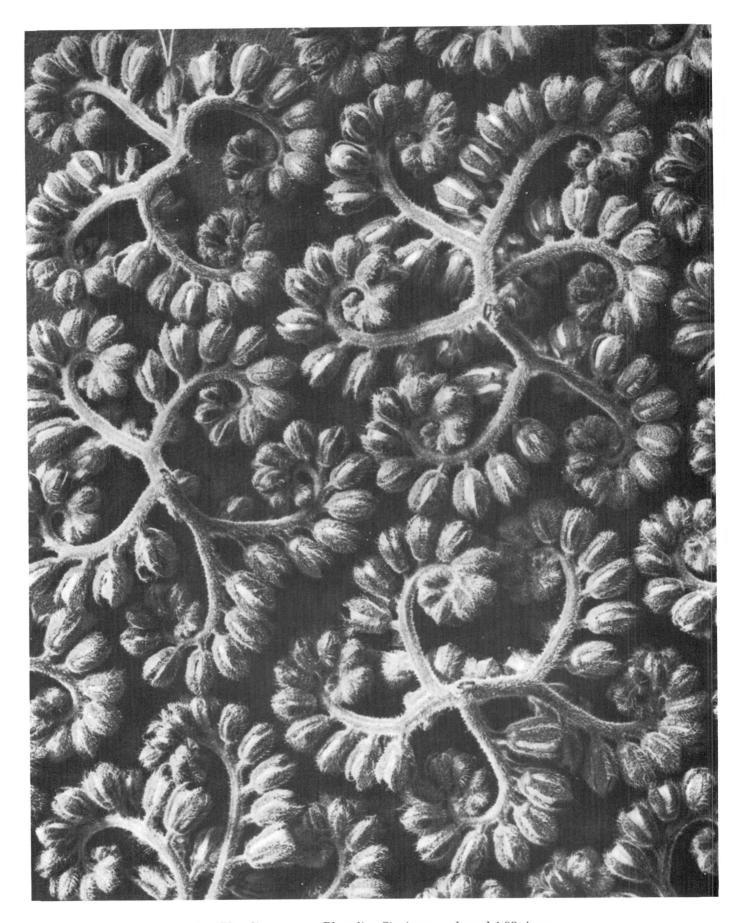

28. *Phacelia congesta*. Phacelia. Cincinnus, enlarged 4.98 times.

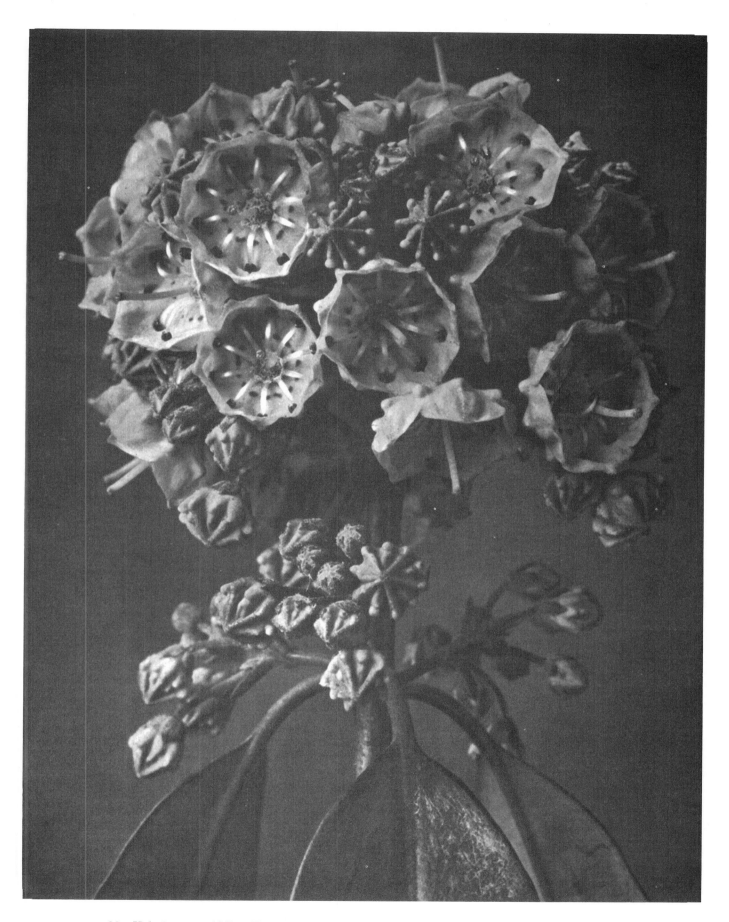

29. *Kalmia angustifolia (Ericaceae)*. Dwarf Laurel. Flower peduncle, enlarged 4.15 times.

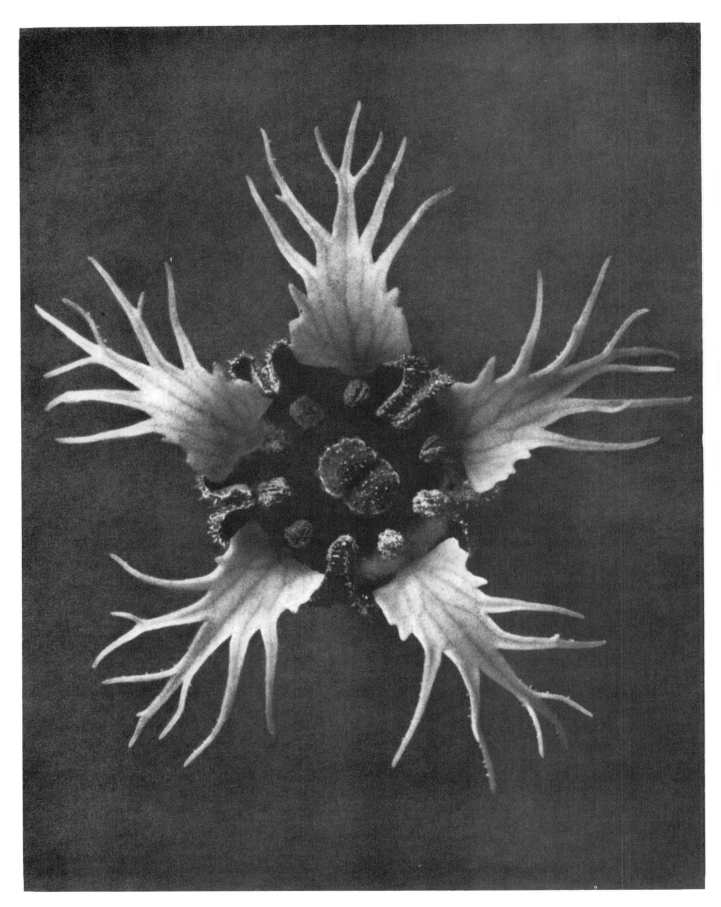

30. *Tellima grandiflora*. Saxifrage. Enlarged 20.75 times.

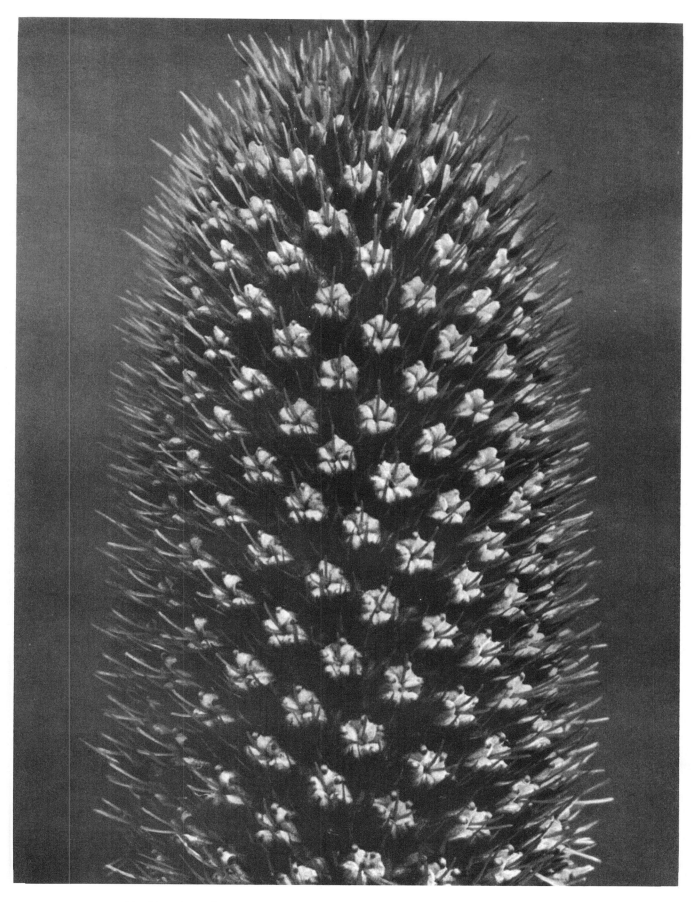

31. *Eryngium alpinum.* Alpine Eryngo. Flower capitulum, enlarged 6.64 times.

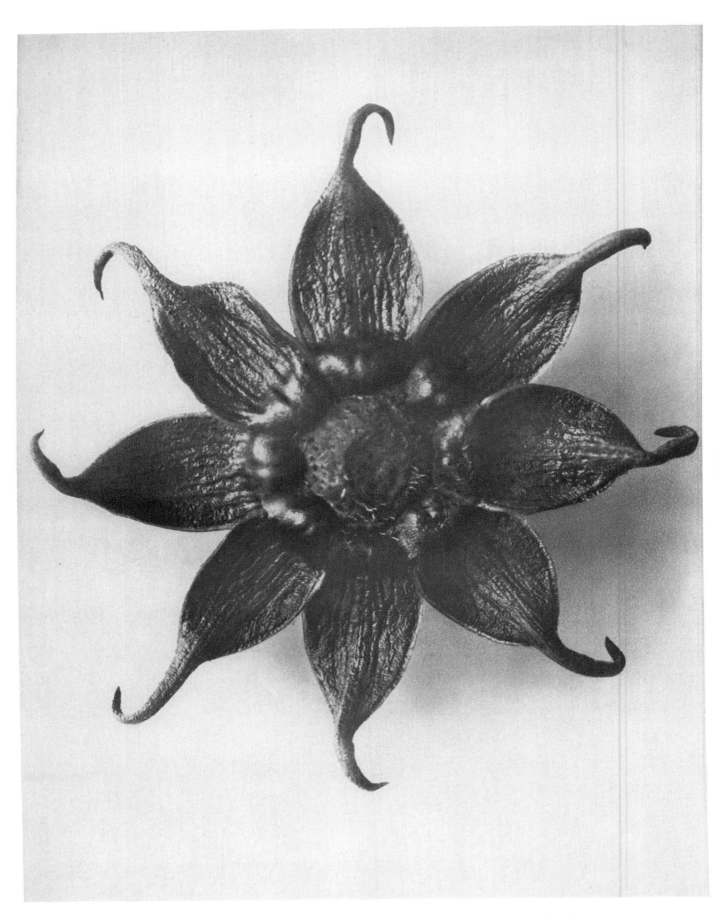

32. *Cosmos bipinatus (Compositae)*. Purple Mexican Aster. Sepals, enlarged 6.64 times.

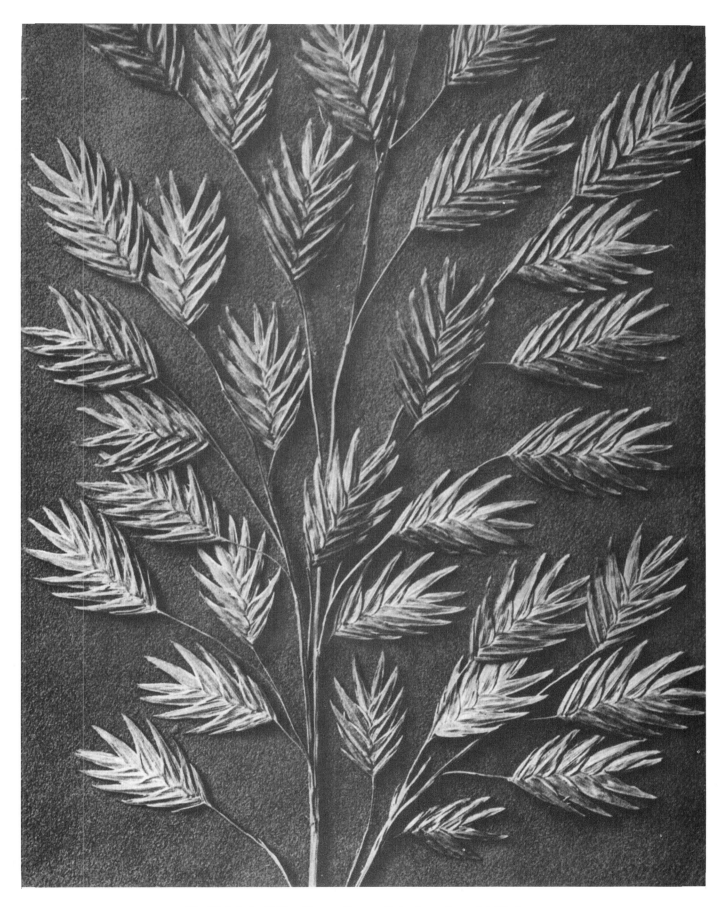

33. *Uniola latifolia*. Fescue Grass. Spicula, enlarged 4.98 times.

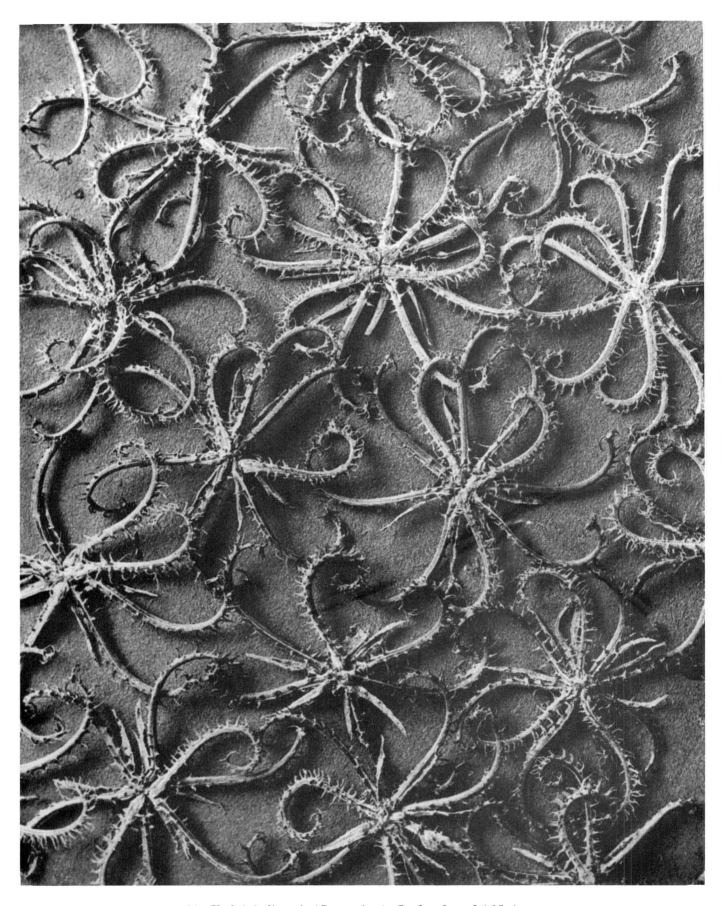

34. *Koelpinia linearis (Compositae)*. Seed, enlarged 4.15 times.

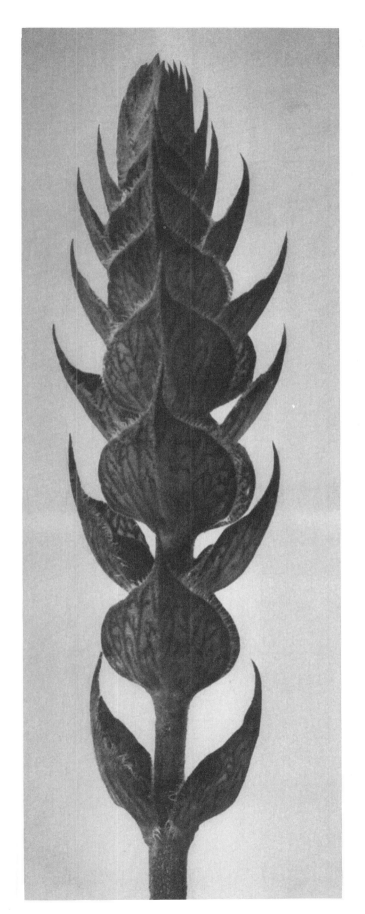
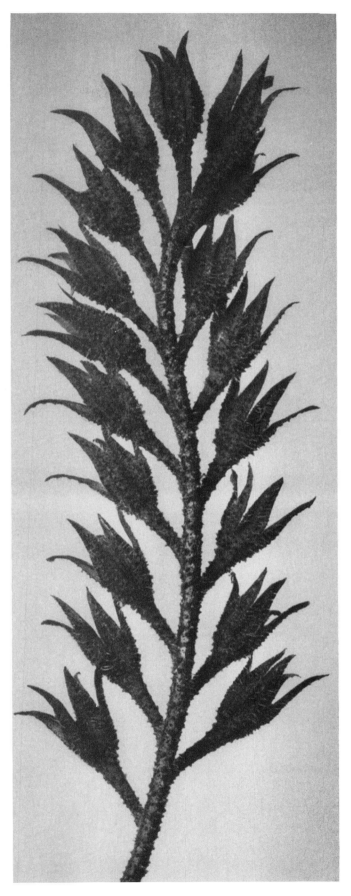

35. a *Salvia pratensis*. Meadow Clary. Enlarged 6.64 times.
 b *Symphitum officinale*. Common Comfrey. Seed panicle, enlarged 4.98 times.

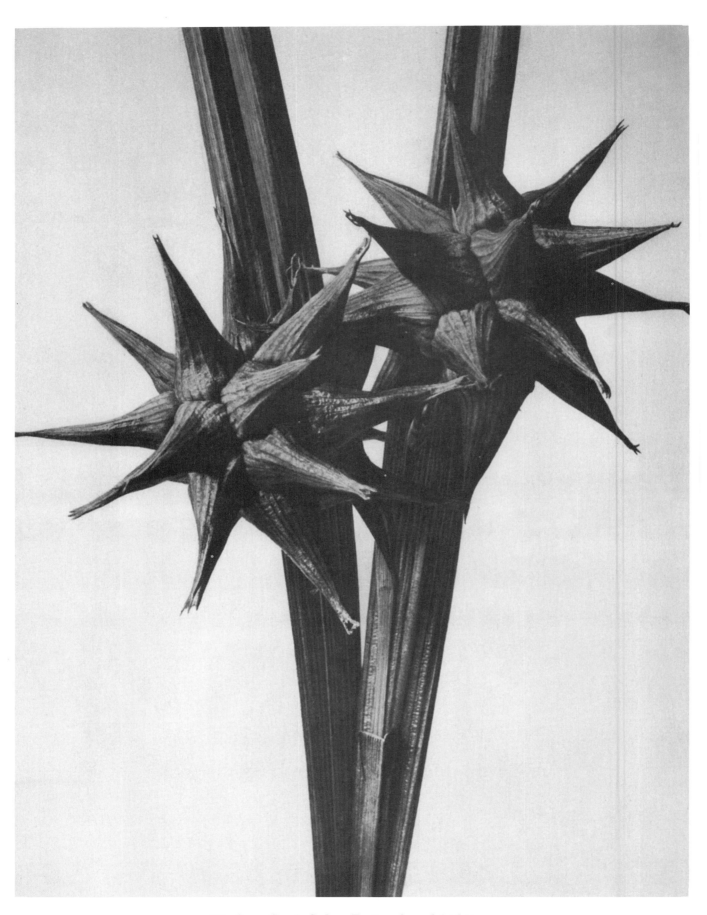

36. *Carex Grayi*. Sedge. Fruit, enlarged 4.15 times.

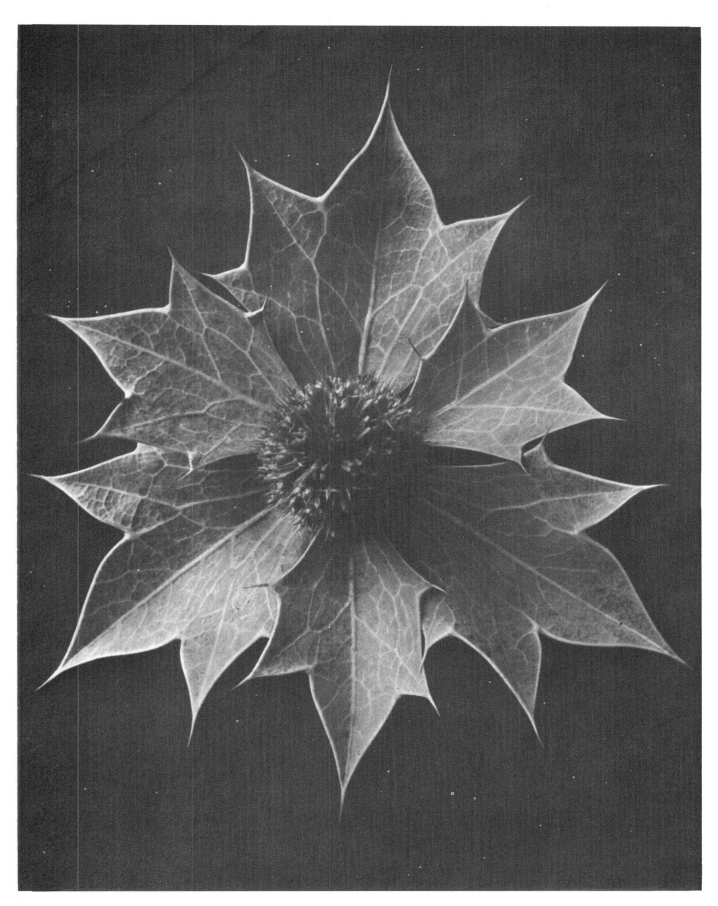

37. *Eryngium maritimum*. Sea Eryngo. Involucral leaves with flower, enlarged 3.32 times.

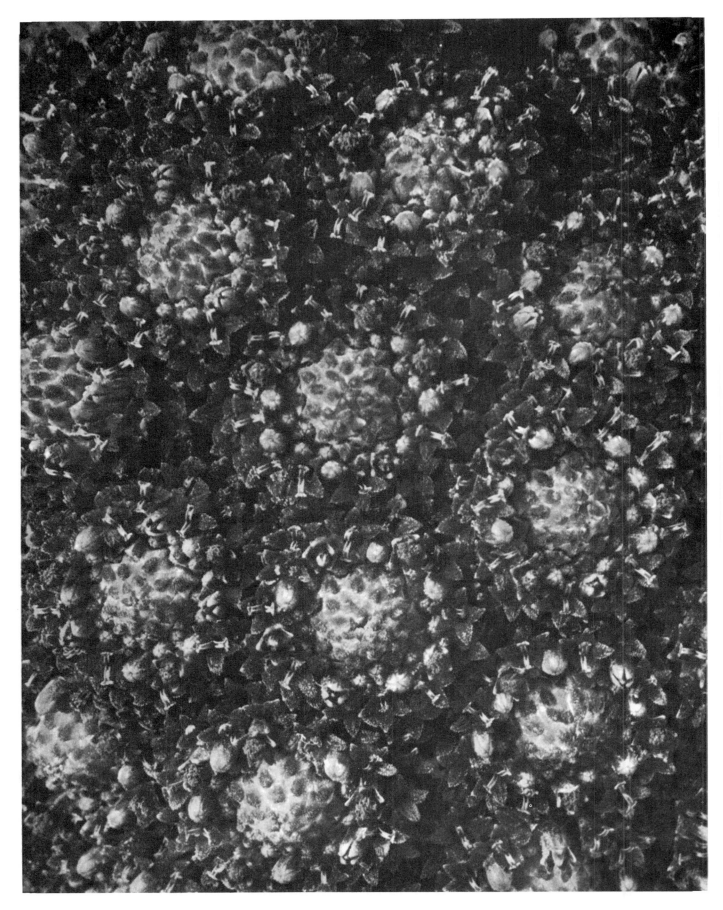

38. *Lonas inodora (Compositae)*. African Daisy. Part of flower-umbel, enlarged 11.62 times.

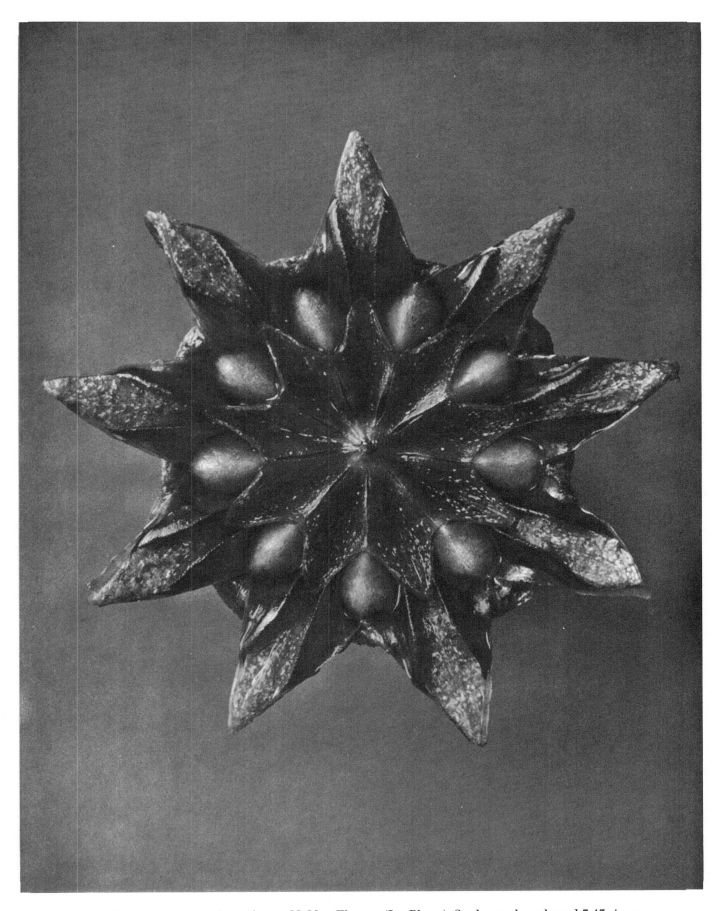

39. *Mesembrianthemum linguiforme.* Midday Flower. (Ice Plant.) Seed capsule, enlarged 7.47 times.

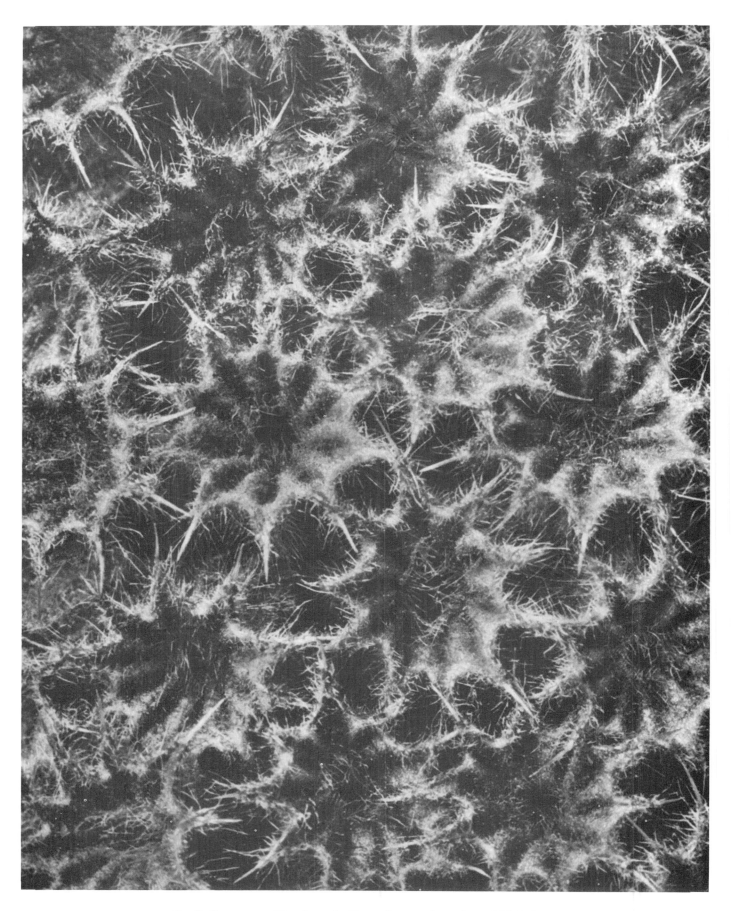

40. *Ballota acuta*. Horehound. Part of coronule, enlarged 16.6 times.

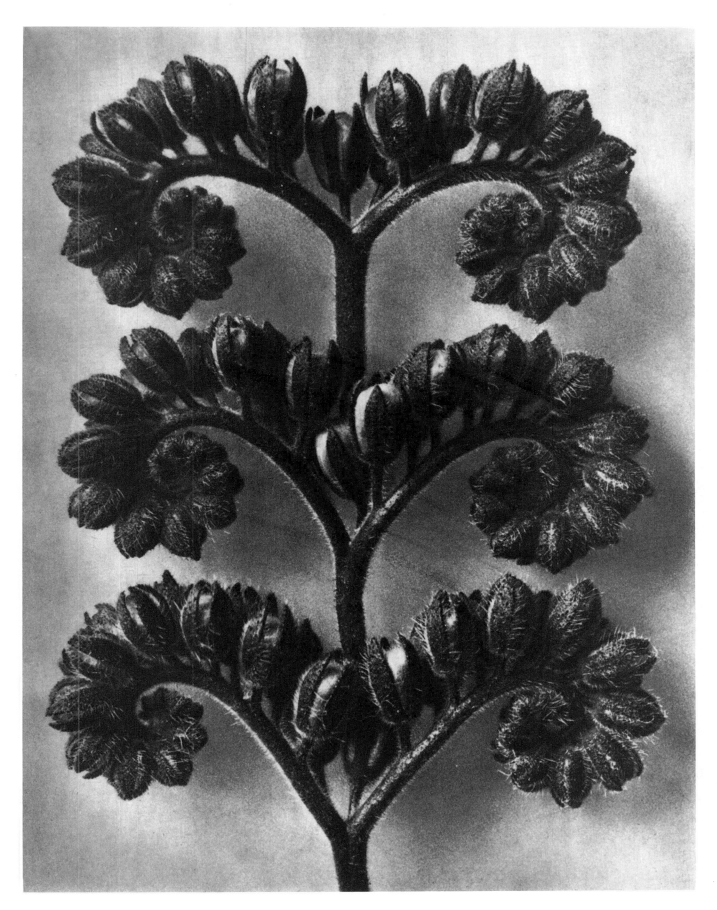

41. *Phacelia congesta*. Phacelia. Cincinnus, enlarged 9.96 times.

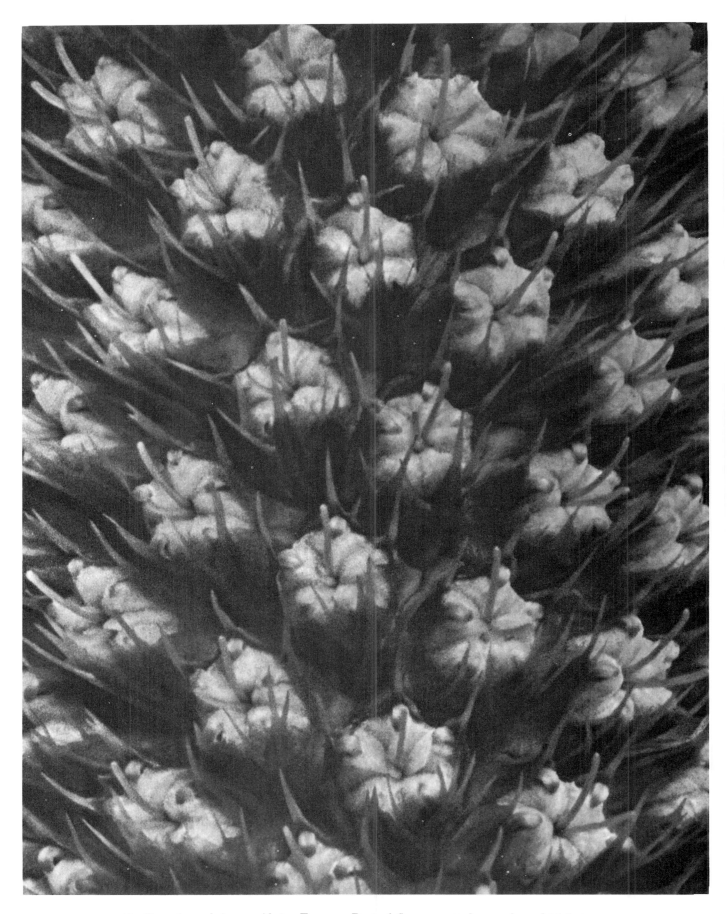

42. *Eryngium alpinum*. Alpine Eryngo. Part of flower capitulum, enlarged 16.6 times.

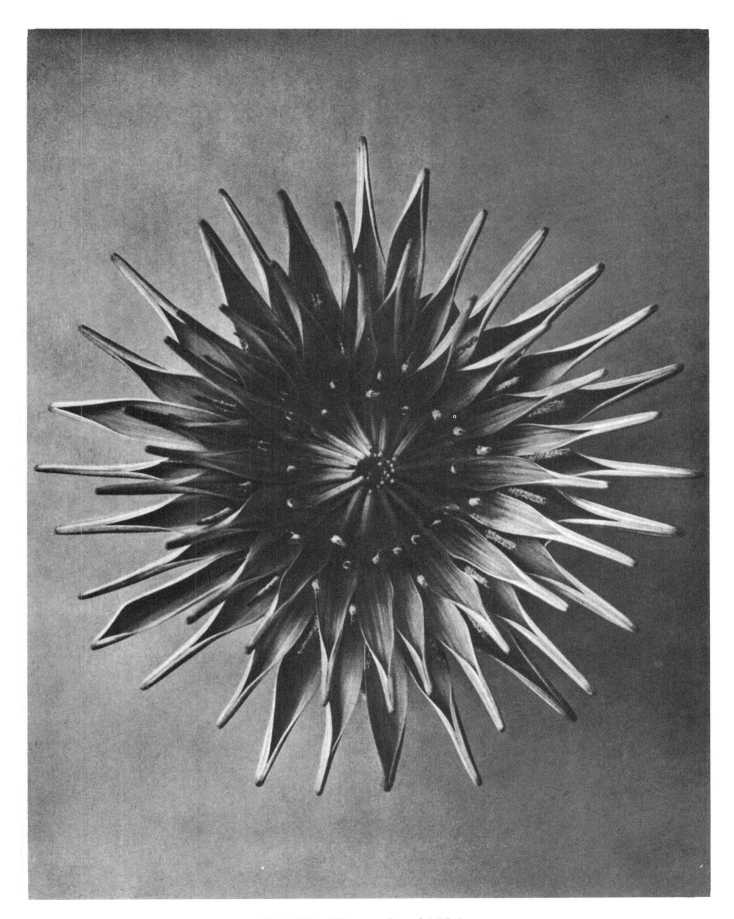

43. *Dahlia.* Flower, enlarged 4.15 times.

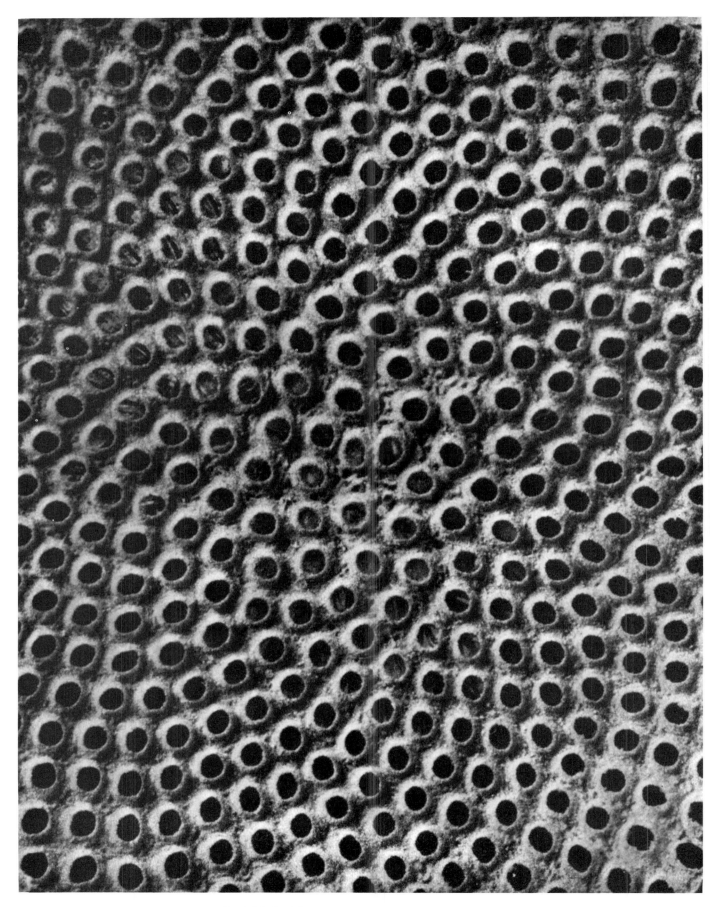

44. *Thistle.* Flower receptacle. Enlarged 8.3 times.

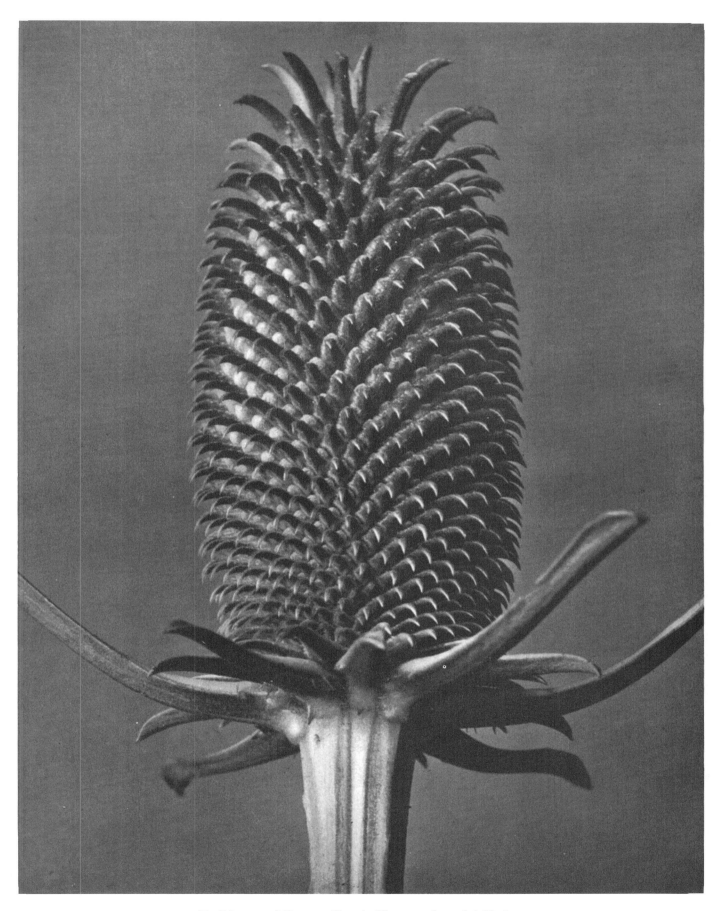

45. *Dipsacus fullonum.* Teasel. Flower, enlarged 4.98 times.

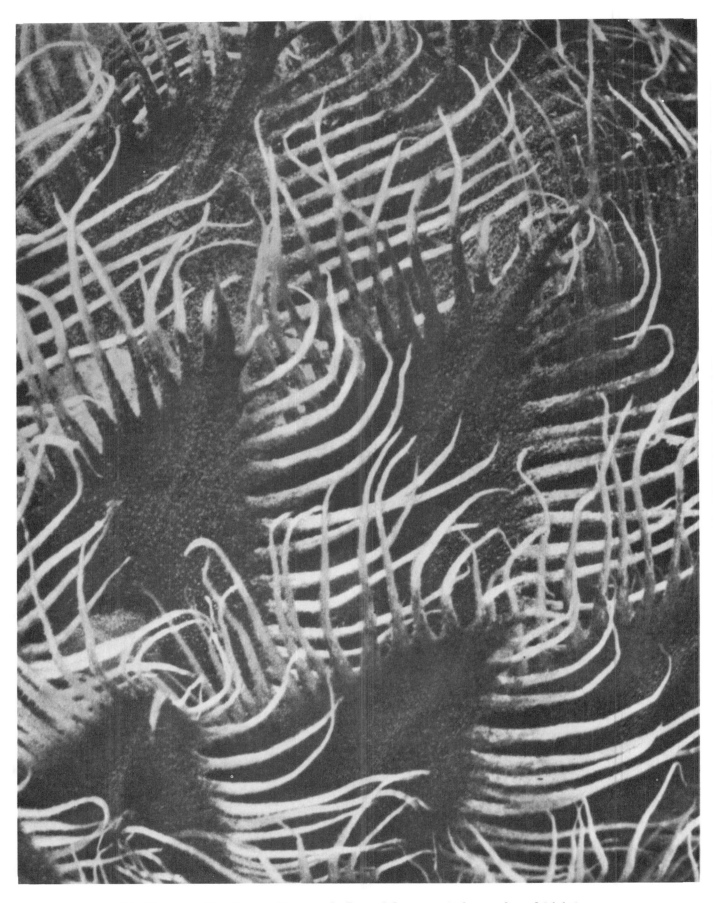

46. *Centaurea Kotschyana.* Knapweed. Part of flower capitulum, enlarged 16.6 times.

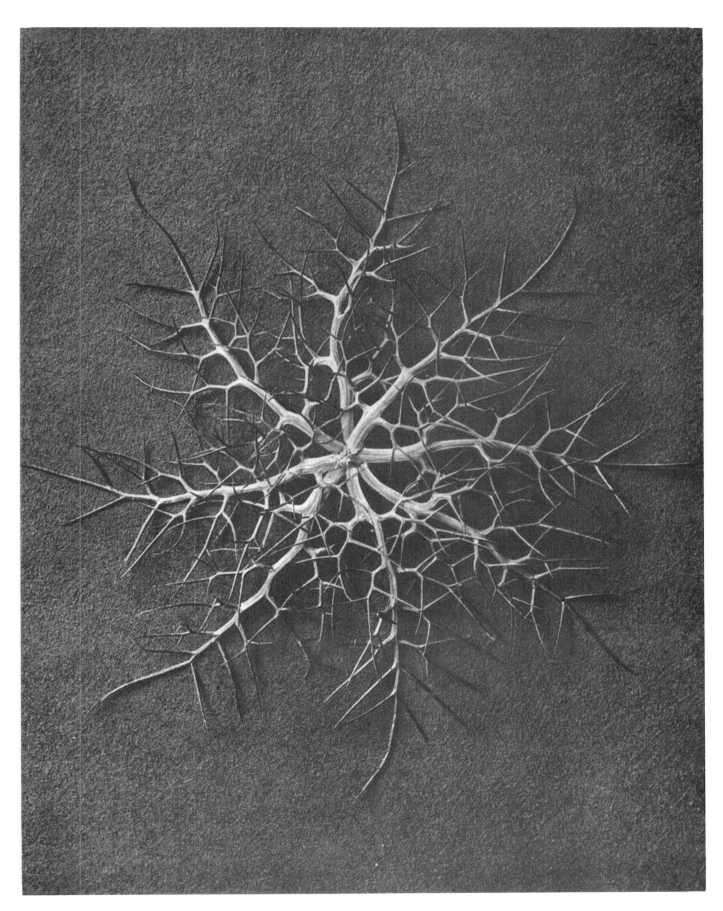

47. *Nigella damascena*. Catherine's Flower, Love-in-a-mist. Sepals, enlarged 4.98 times.

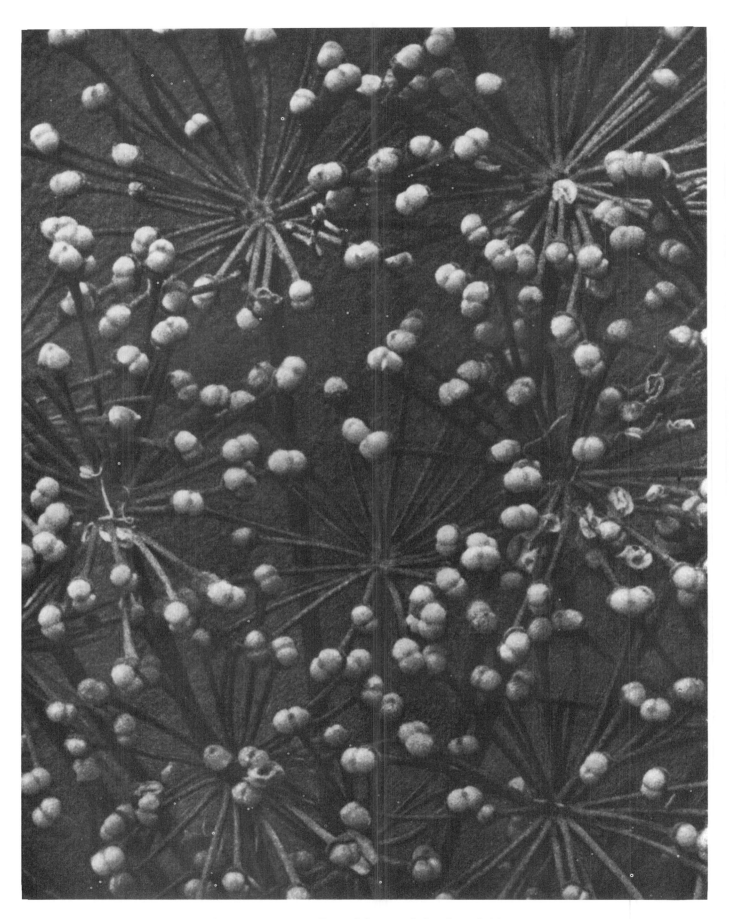

48. *Cnidium venosum.* Part of fruit-umbel, enlarged 5.81 times.

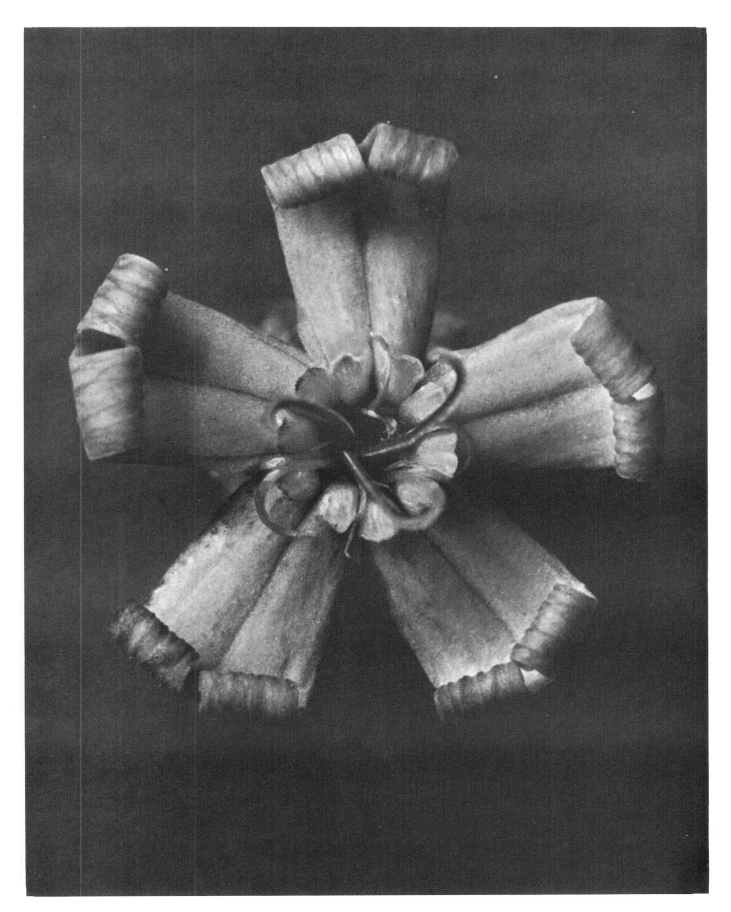

49. *Silene vallesia*. Catchfly. Flower, enlarged 12.45 times.

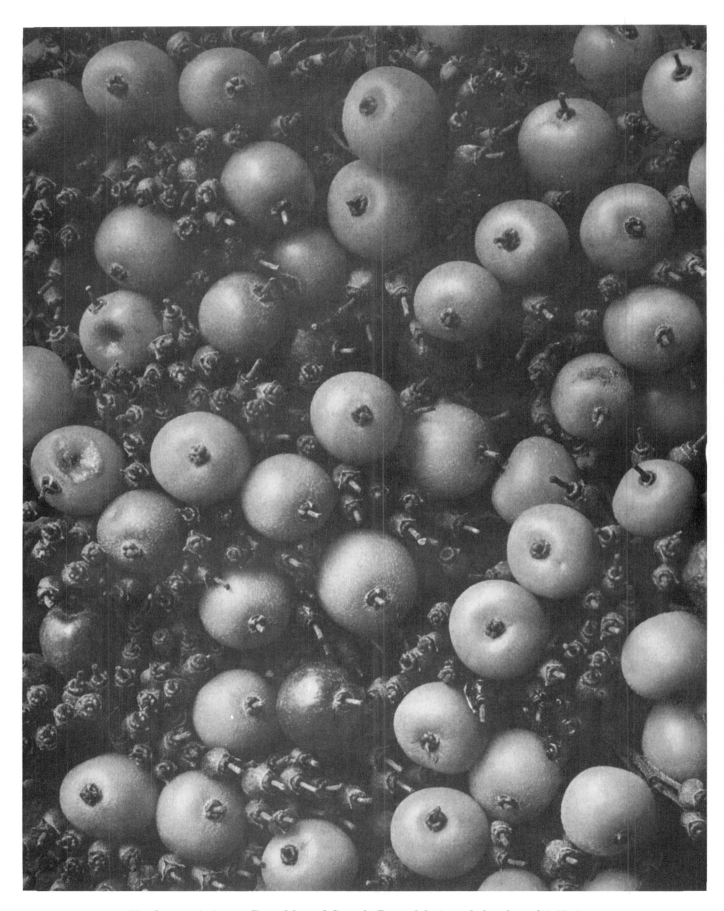

50. *Cornus circinata*. Round-leaved Cornel. Part of fruit-umbel, enlarged 4.98 times.

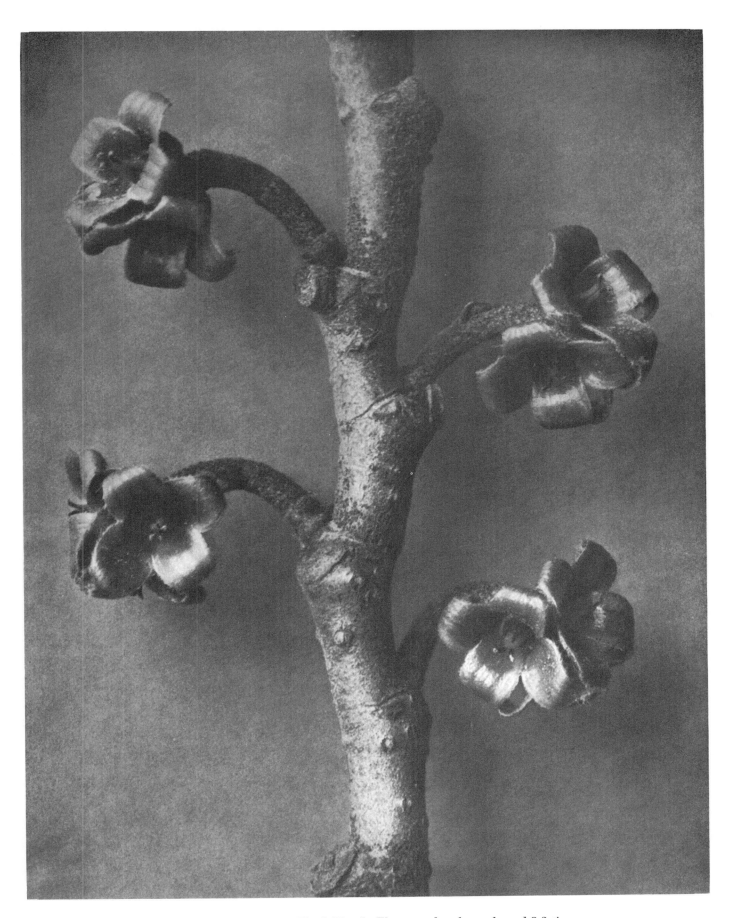

51. *Hamamelis japonica*. Witch Hazel. Flower peduncles, enlarged 8.3 times.

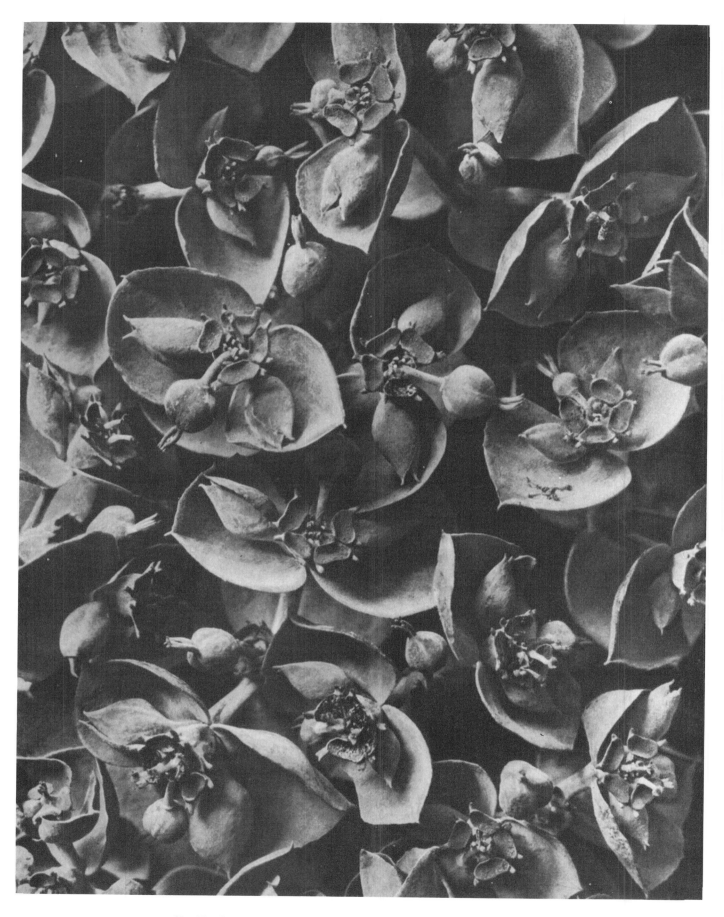

52. *Euphorbia pityusa*. Wolf's Milk. Fascicle, enlarged 4.98 times.

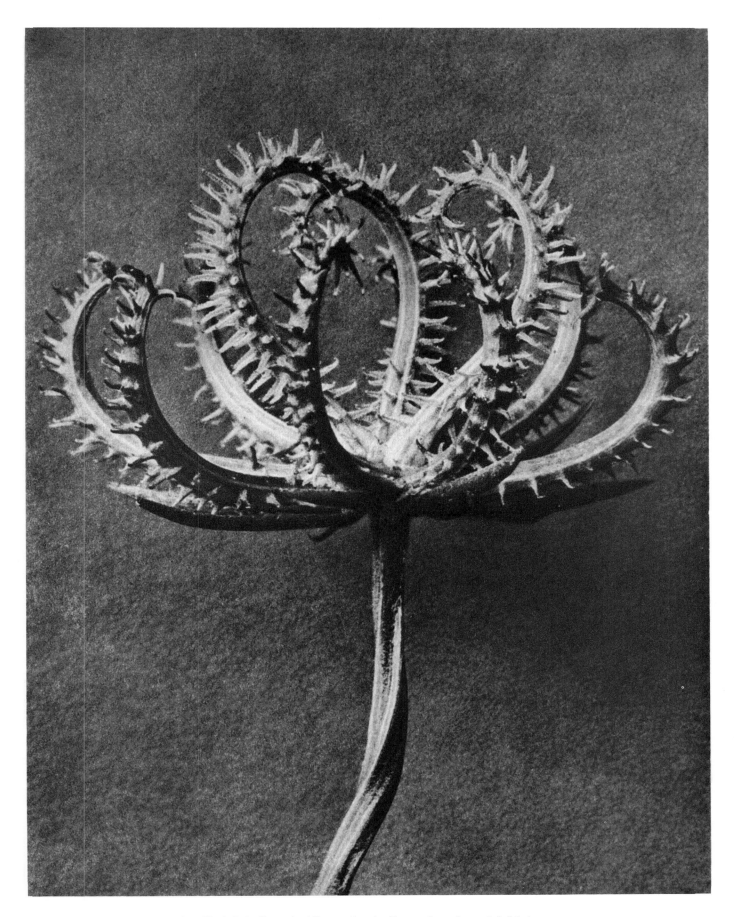

53. *Koelpinia linearis (Compositae)*. Coronule, enlarged 9.96 times.

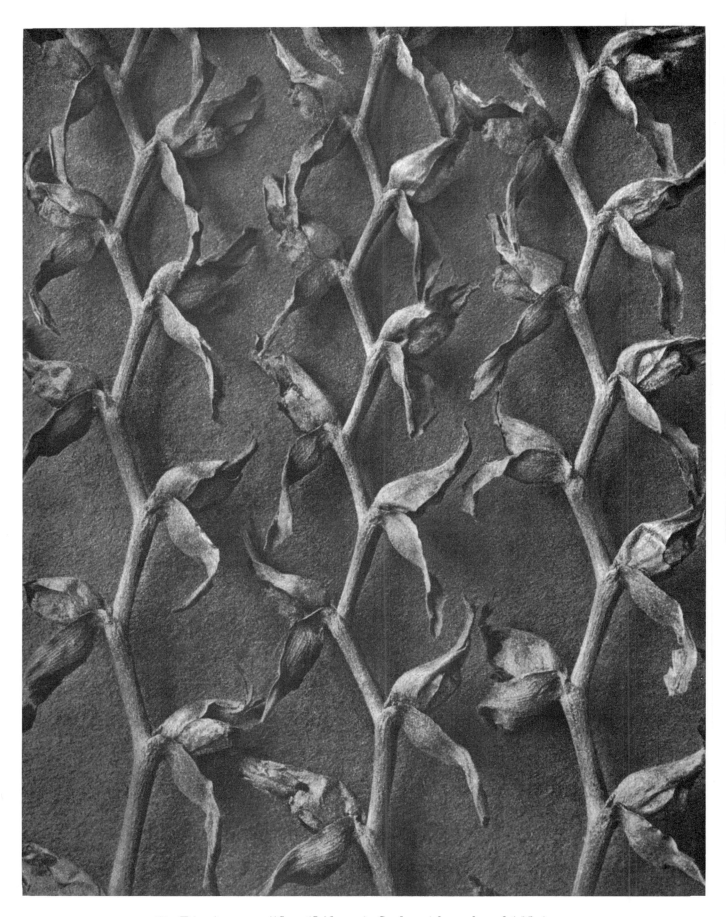

54. *Tritonia crocosmiiflora (Iridaceae)*. Seed panicles, enlarged 4.15 times.

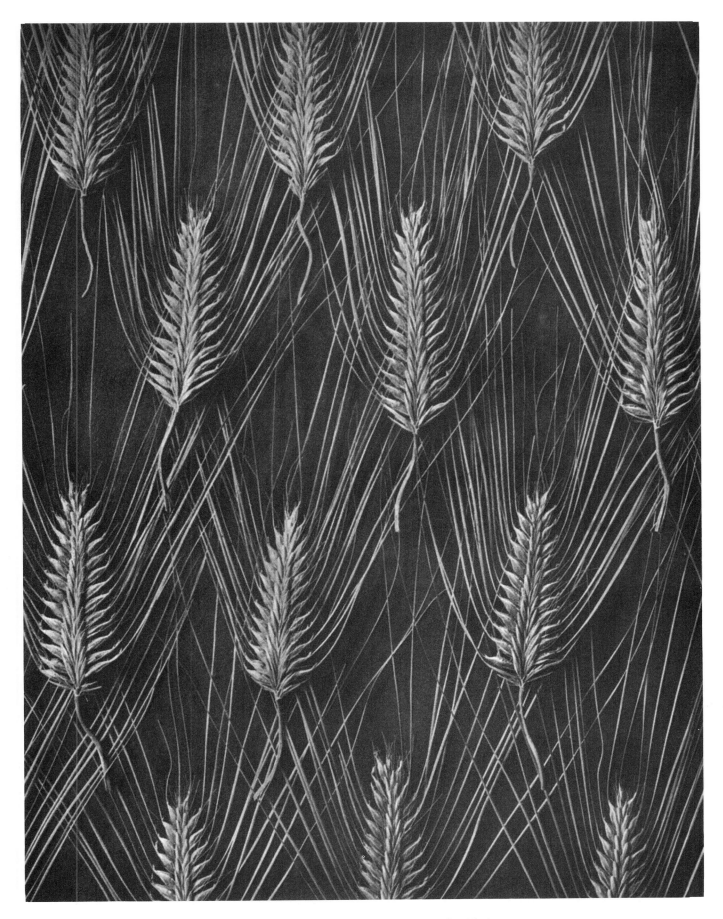

55. *Hordeum distichum.* Barley. Enlarged 1.25 times.

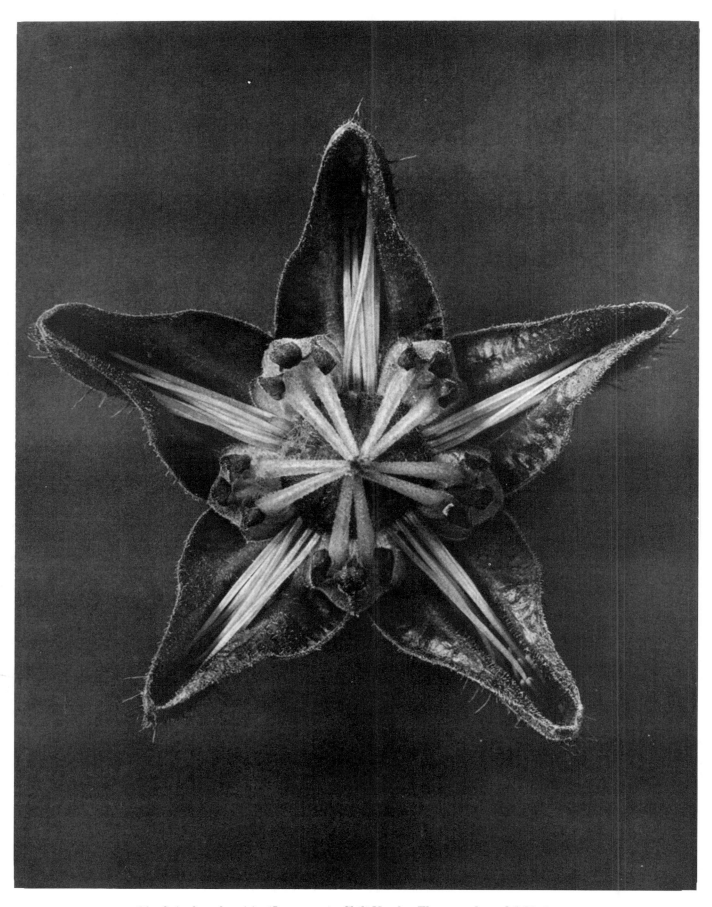

56. *Cajophora lateritia (Loasaceae)*. Chili Nettle. Flower, enlarged 5.81 times.

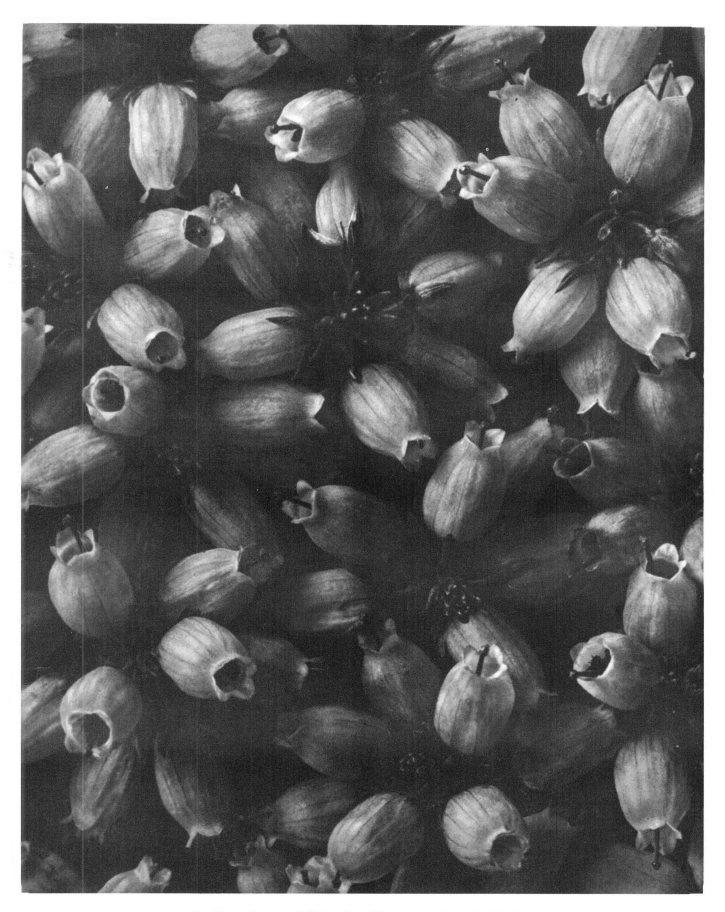

57. *Erica cinerea.* Bell-heather. Racemes, enlarged 4.98 times.

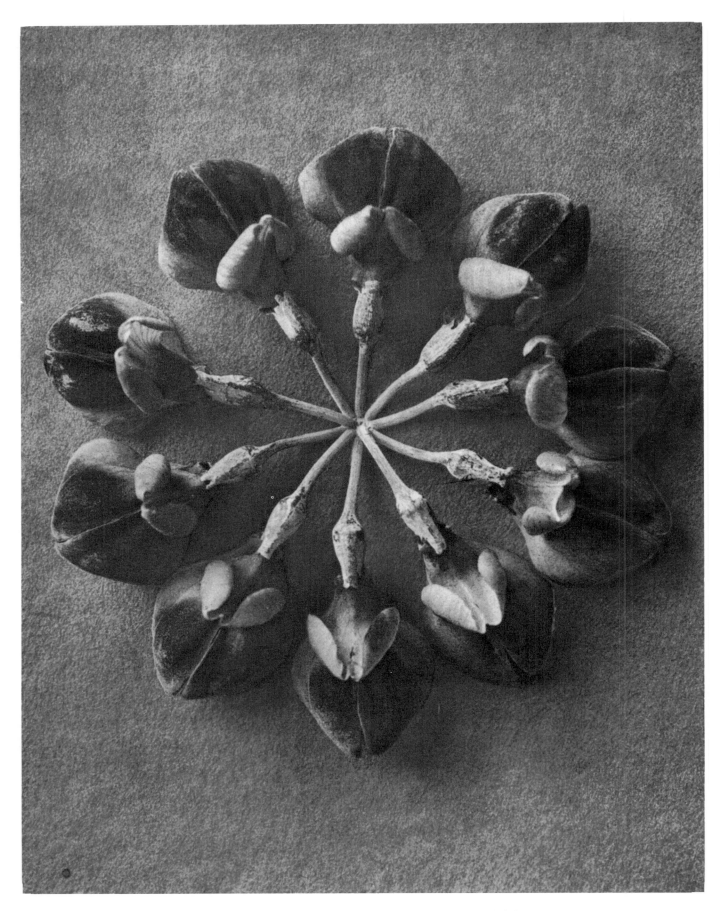

58. *Coronilla coronata*. Coronilla. Flower-umbel, enlarged 6.64 times.

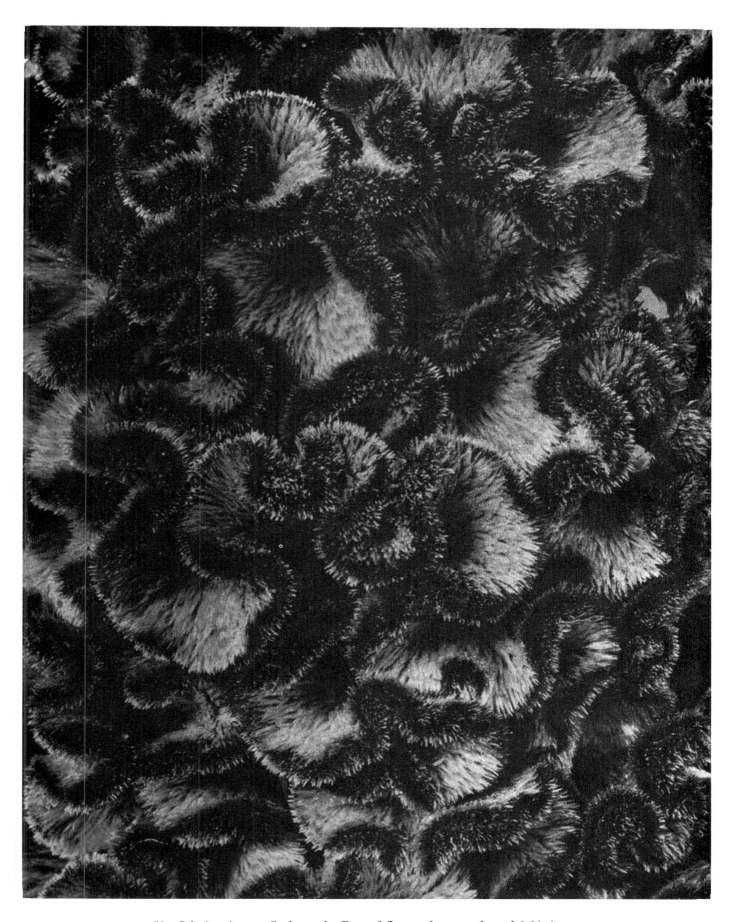

59. *Celosia cristata*. Cockscomb. Part of flower-cluster, enlarged 6.64 times.

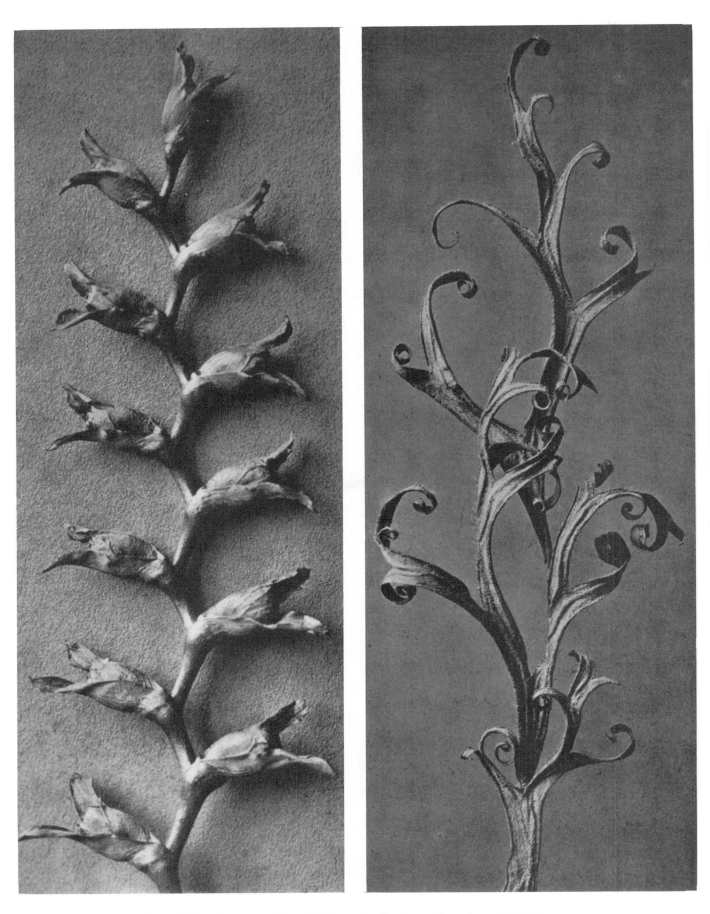

60. a *Tritonia crocosmiiflora (Iridaceae)*. Seed panicle, enlarged 4.98 times.
 b *Delphinium*. Larkspur. Part of a dried leaf, enlarged 2.49 times.

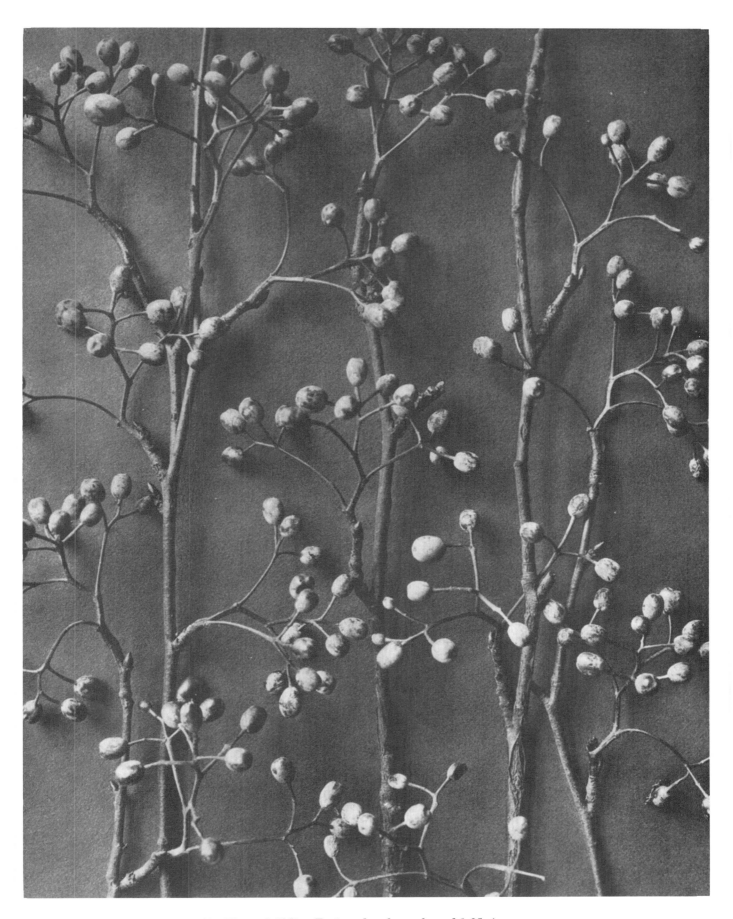

61. *Pirus alnifolia*. Fruit peduncles, enlarged 1.25 times.

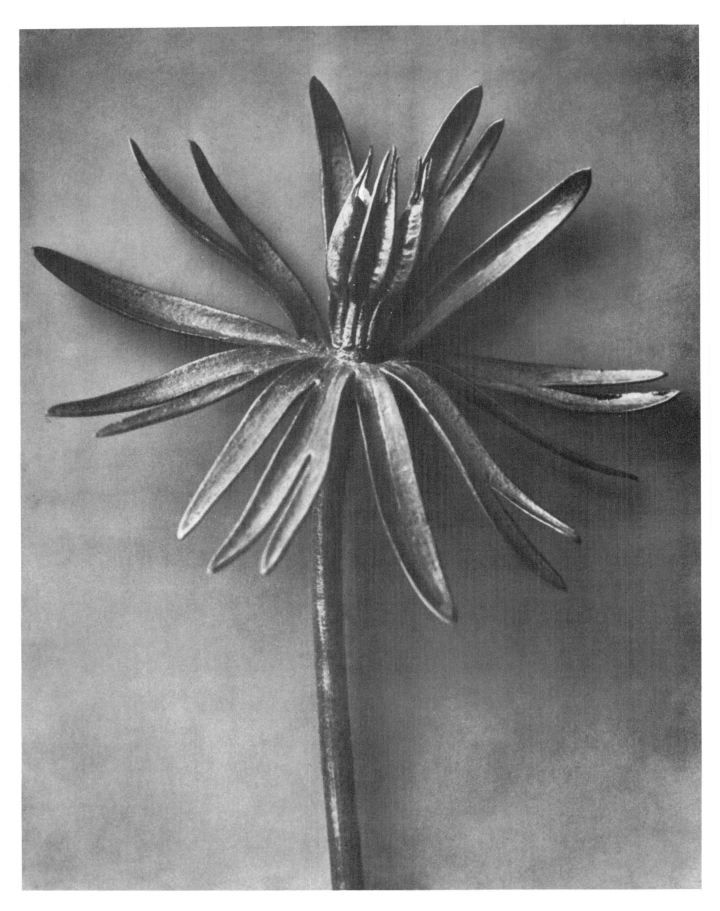

62. *Eranthis hiemalis*. Winter Hellebore. Sepals with fruit, enlarged 6.64 times.

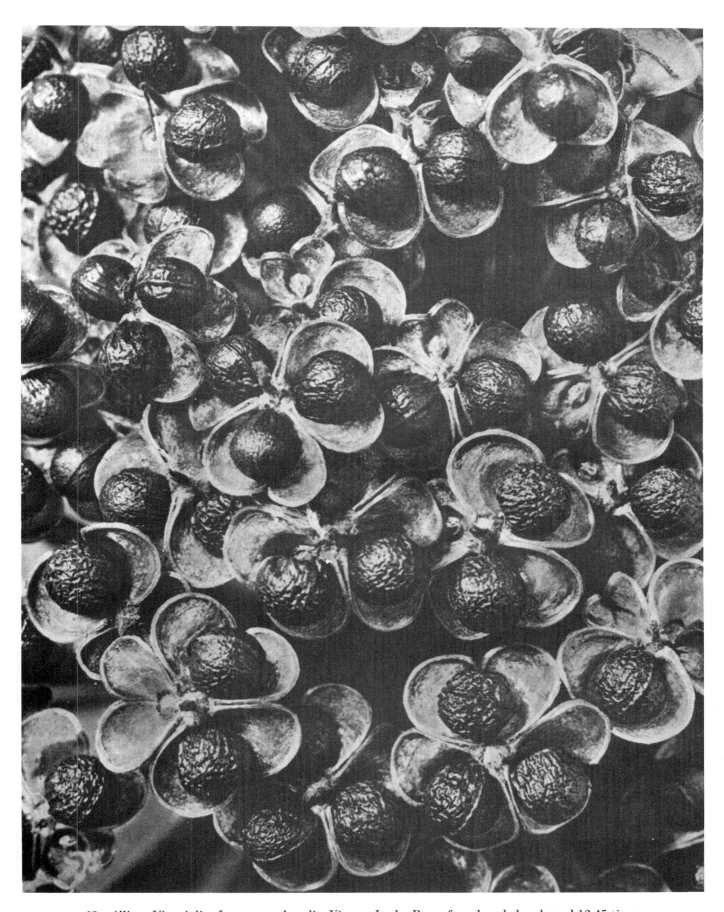

63. *Allium Victorialis.* Long-rooted garlic, Victory Leek. Part of seed-umbel, enlarged 12.45 times.

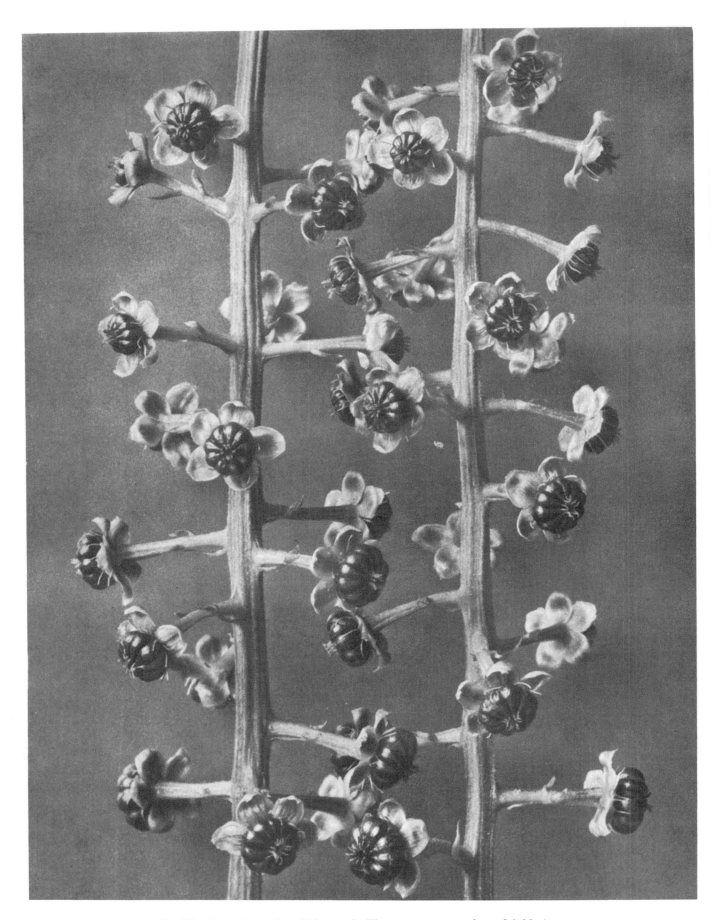

64. *Phytolacca decandra*. Pokeweed. Flower racemes, enlarged 3.32 times.

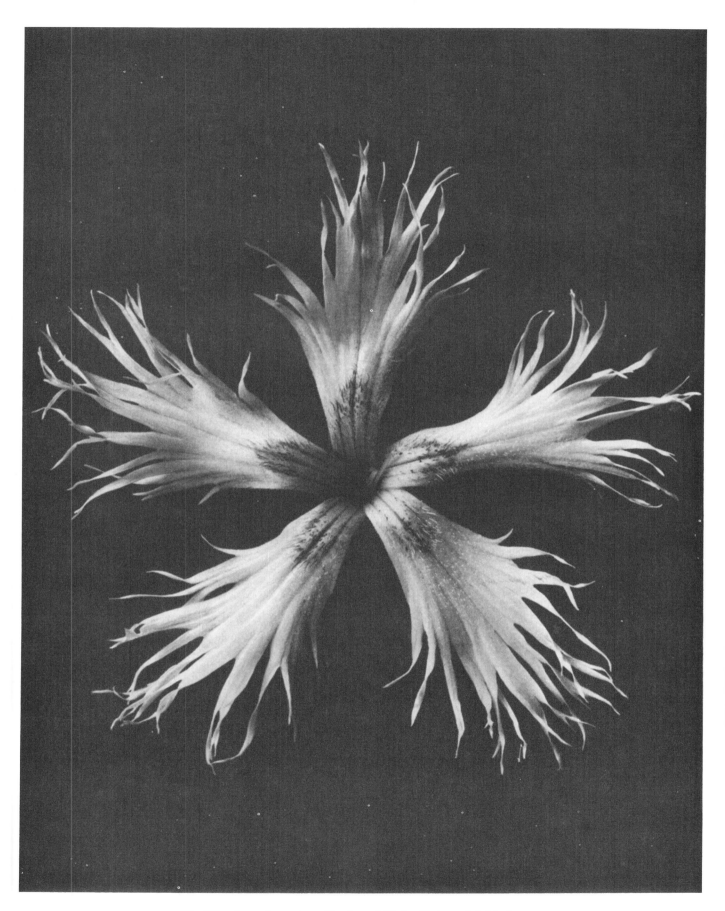

65. *Dianthus plumarius*. Feathered Pink. Enlarged 6.64 times.

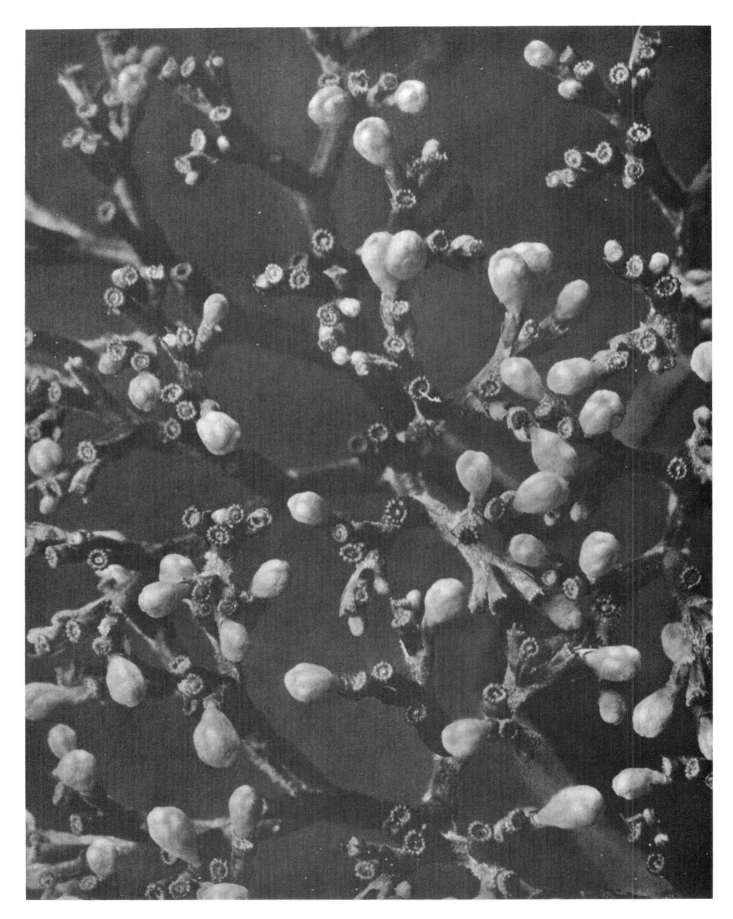

66. *Valeriana alliarüfolia*. Valerian. Fruit-umbel, enlarged 6.64 times.

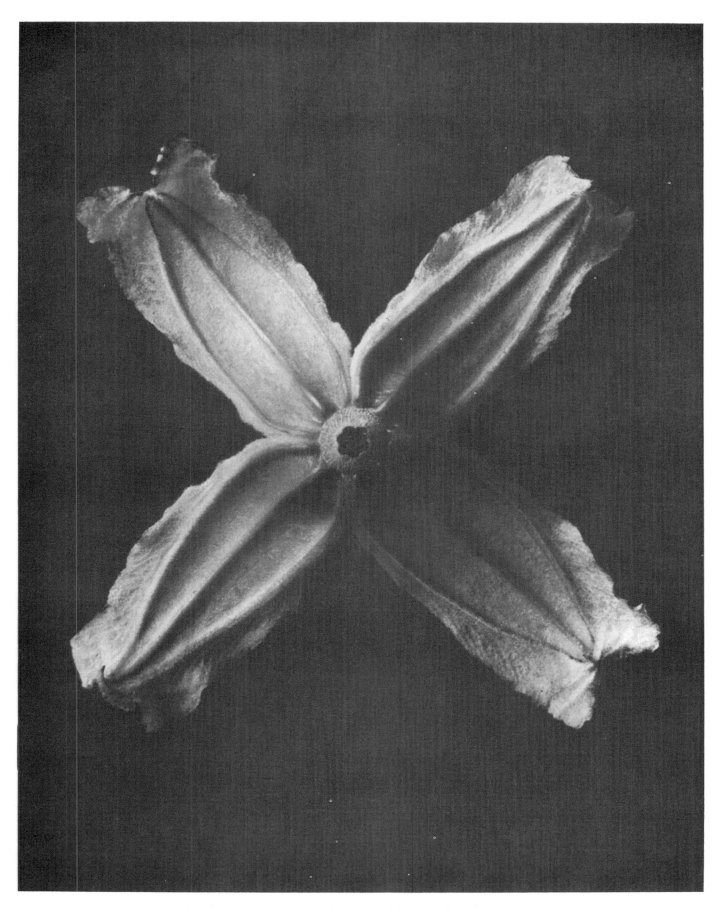

67. *Clematis integrifolia*. Clematis. Flower, enlarged 7.47 times.

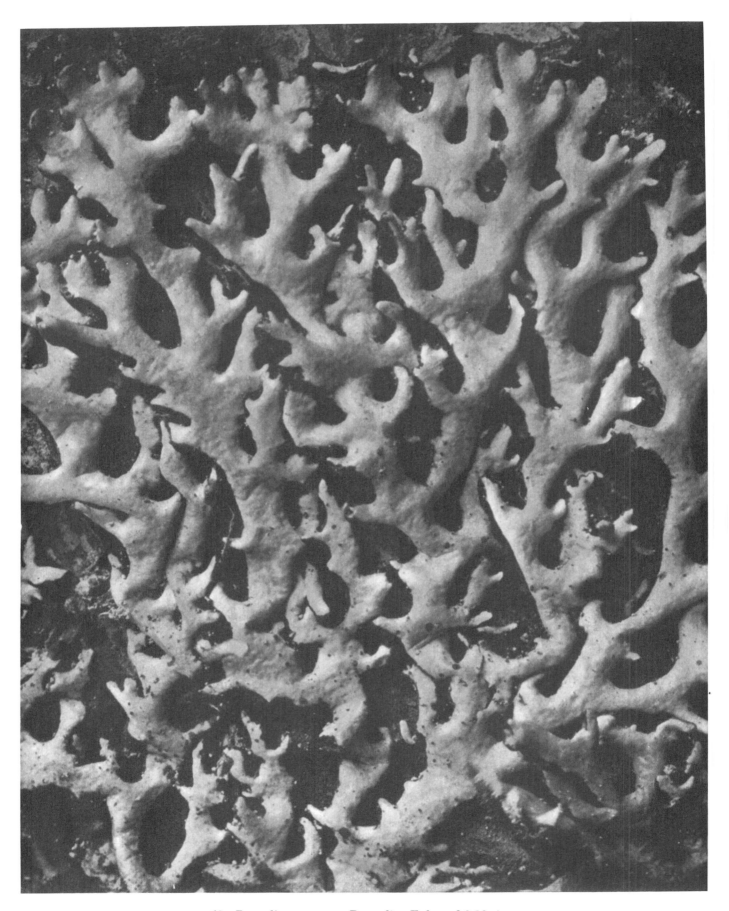

68. *Parmelia conspersa*. Parmelia. Enlarged 9.13 times.

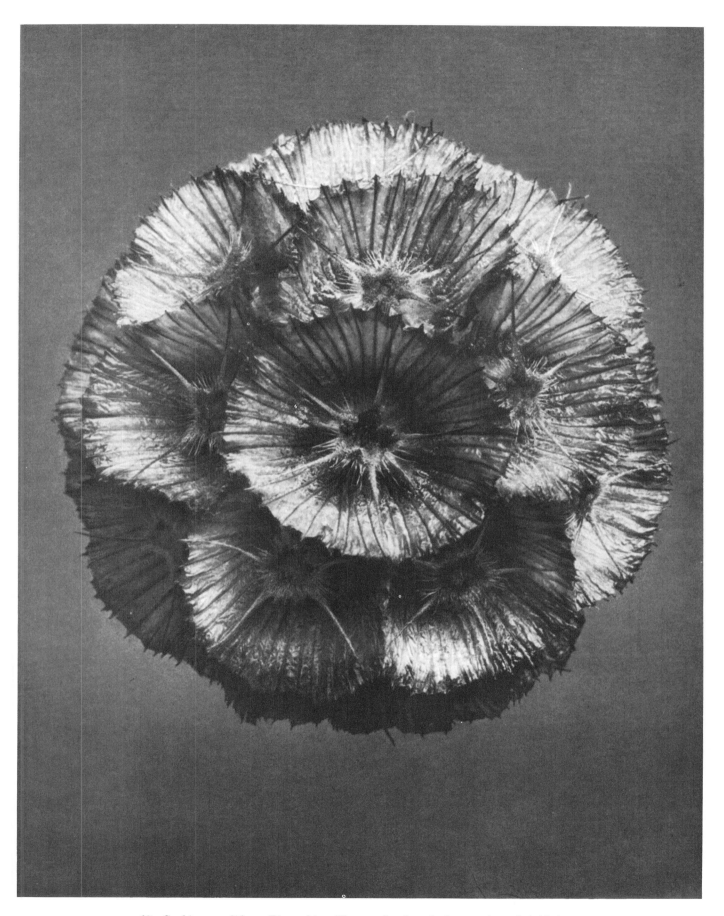

69. *Scabiosa prolifera*. Pincushion Flower. Seed capitulum, enlarged 6.64 times.

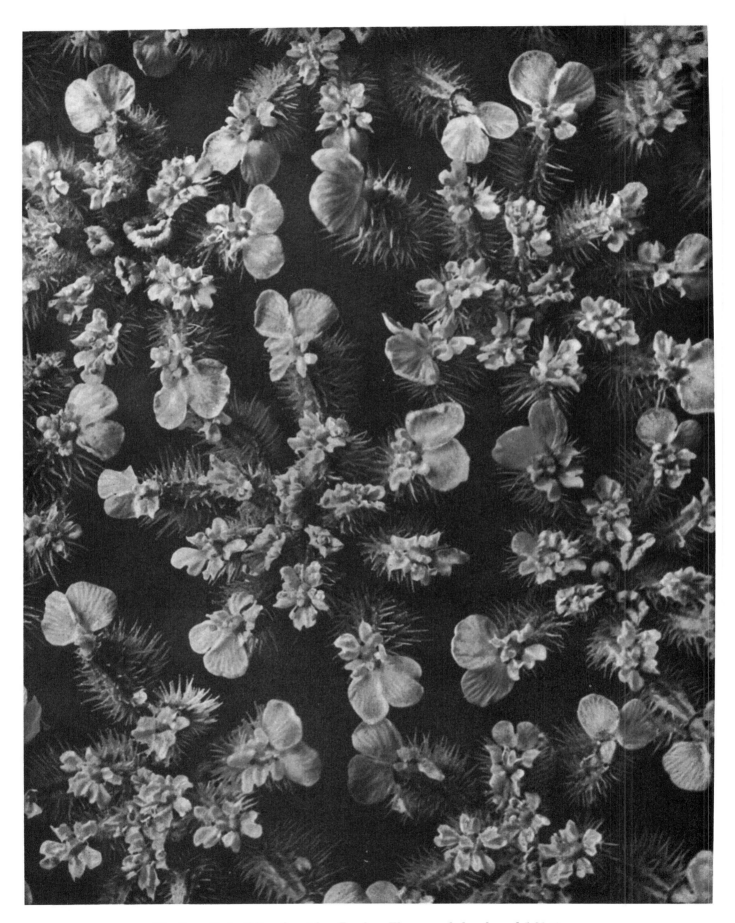

70. *Caucalis latifolia*. Great-bur Parsley. Flower-umbel, enlarged 5.81 times.

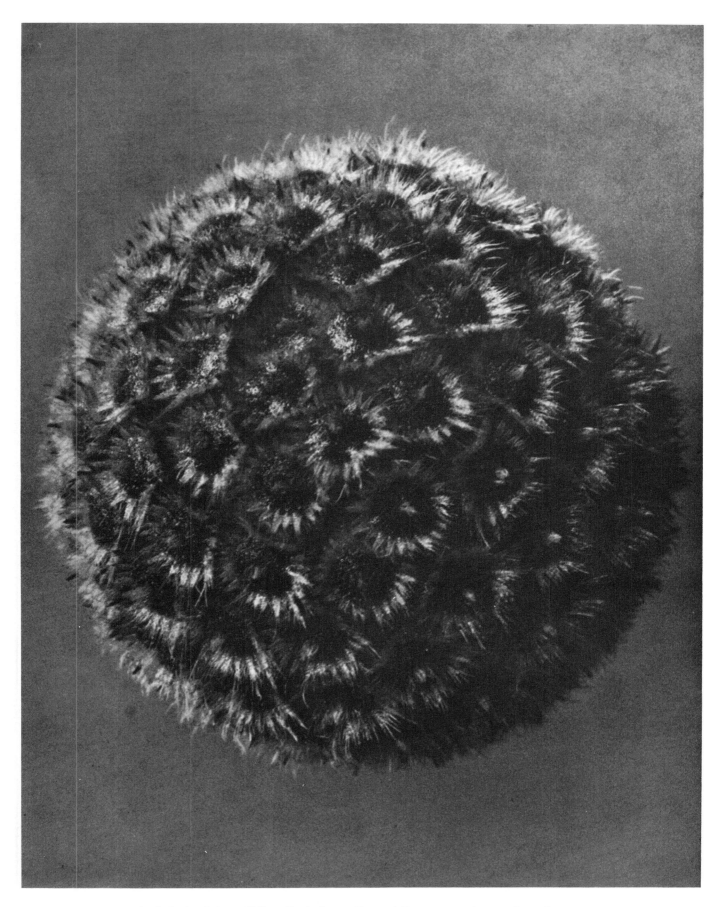

71. *Cephalaria alpina*. Yellow Cephalaria. Part of flower capitulum, enlarged 8.3 times.

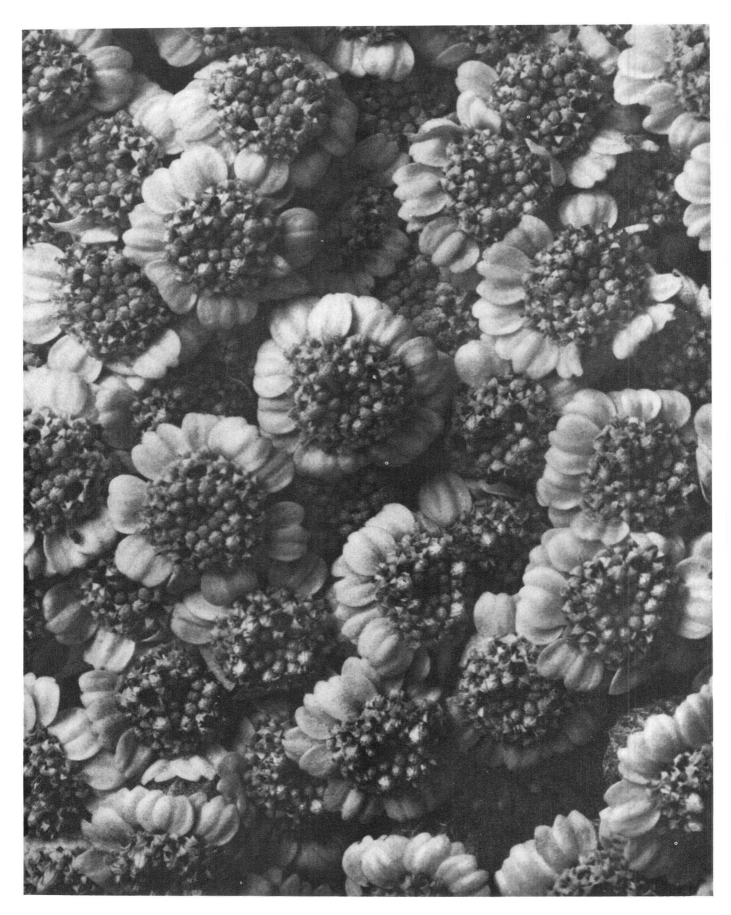

72. *Chrysanthemum macrophyllum*. Marigold. Part of flower-umbel, enlarged 8.3 times.

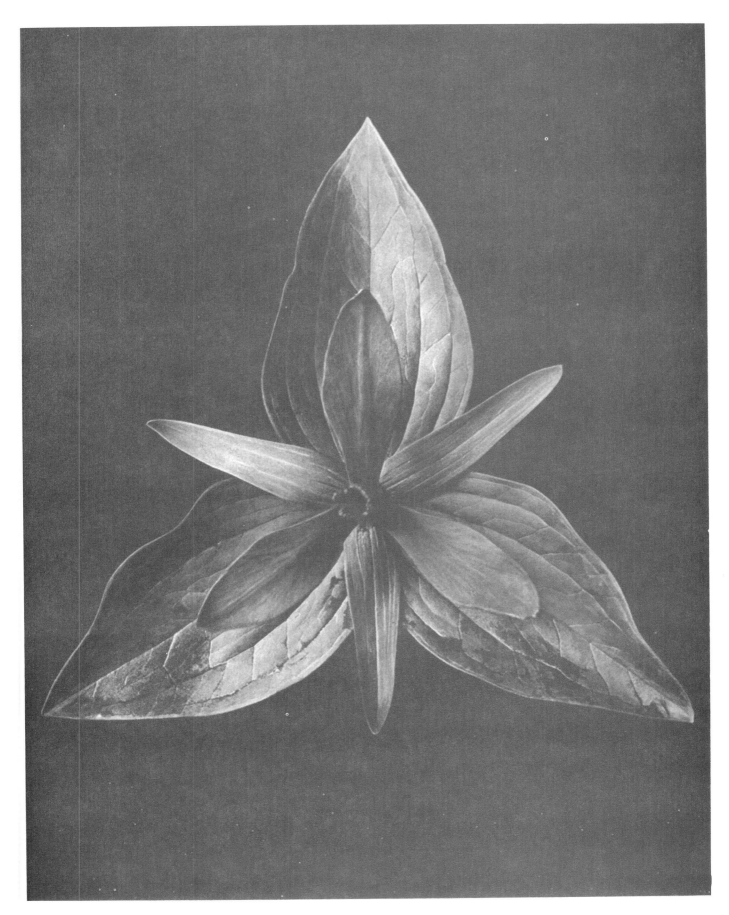

73. *Trillium sessile*. Toadshade, Wake-robin. Enlarged 1.66 times.

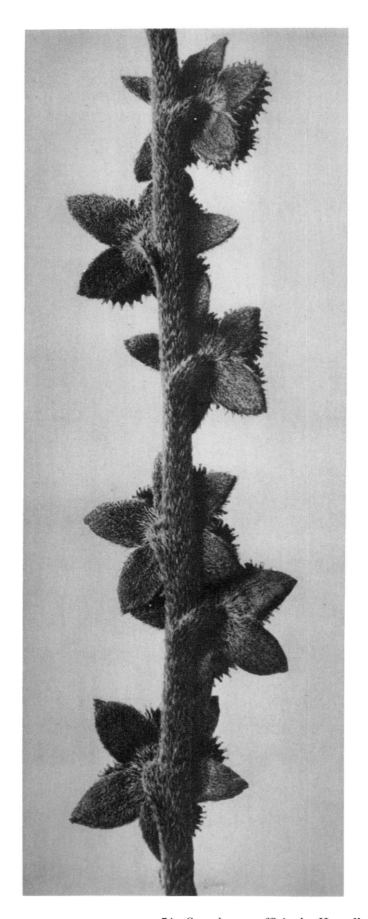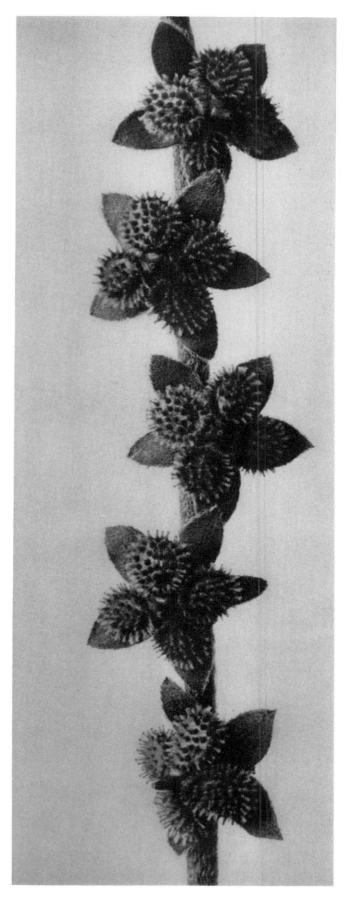

74. *Cynoglossum officinale.* Hound's Tongue. Seed, enlarged 6.64 times.

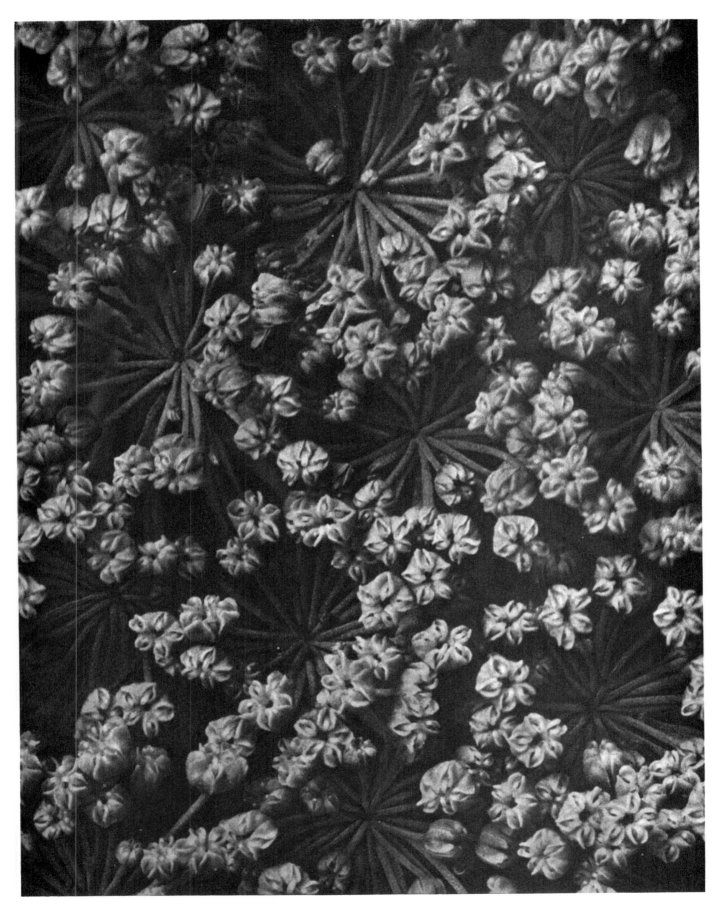

75. *Silaus pratensis*. Meadow Saxifrage. Flower-umbel, enlarged 8.3 times.

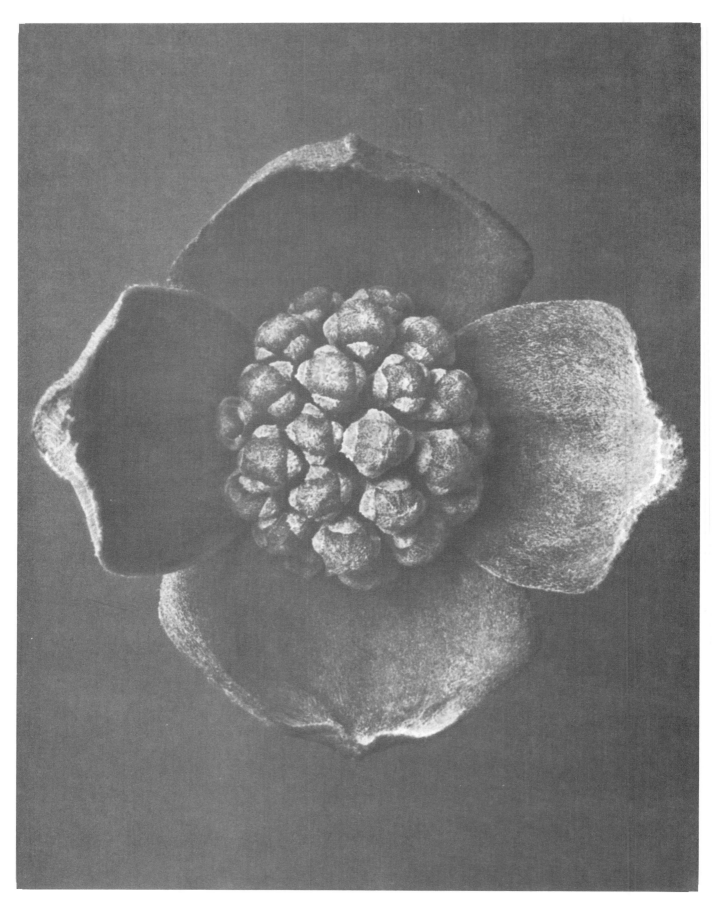

76. *Cornus florida*. Flowering Dogwood. Capitulum, enlarged 8.3 times.

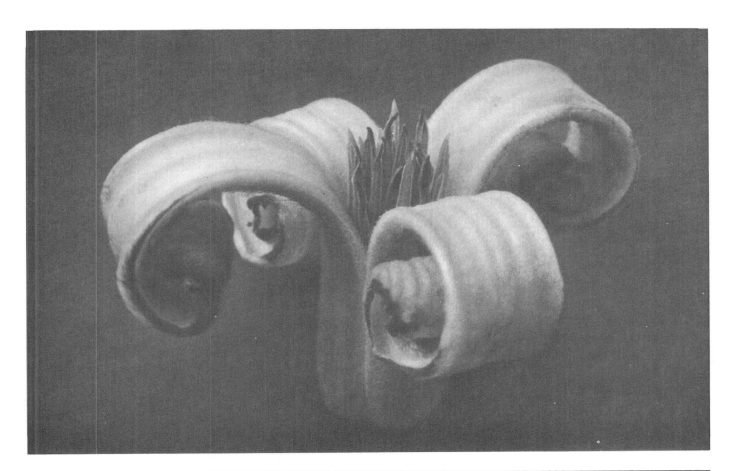

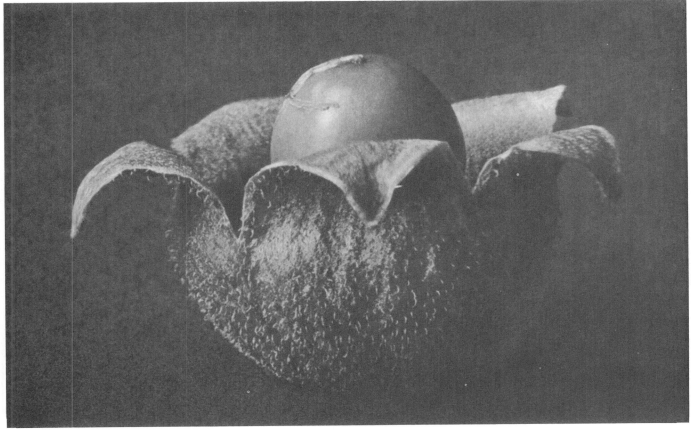

77. a *Clematis heracleifolia*. Clematis. Flower, enlarged 9.96 times.
 b *Cuculus bacifer*. Chickweed. Fruit in calyx, enlarged 9.96 times.

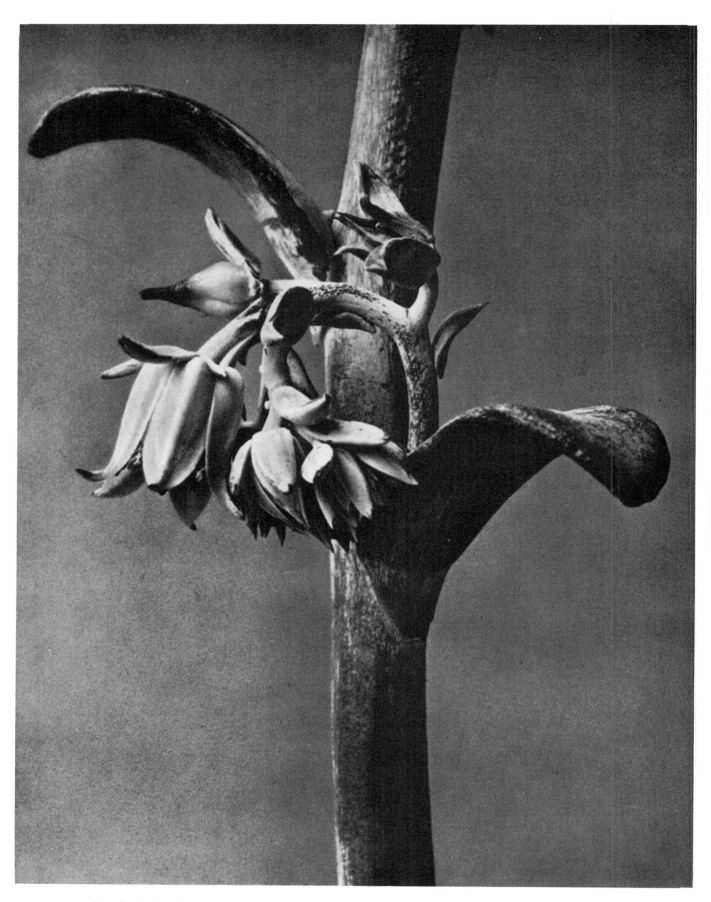

78. *Cotyledon gibbiflora.* *Echeveria.* Cotyledon. Stem with flower raceme, enlarged 4.98 times.

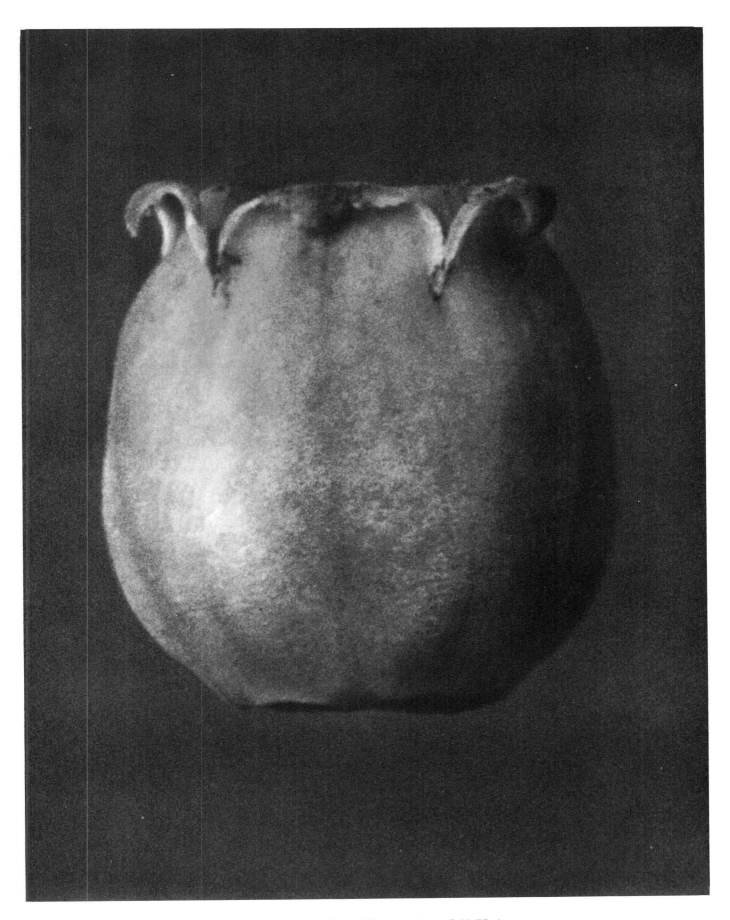

79. *Enkianthus japonicus.* Flower, enlarged 20.75 times.

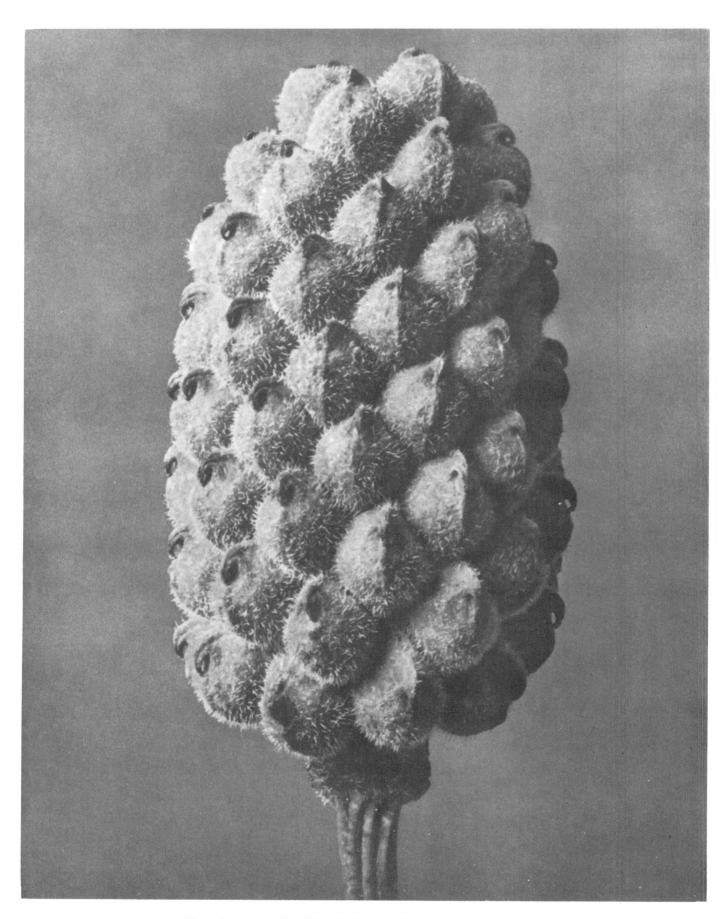

80. *Adonis vernalis*. False Hellebore. Fruit, enlarged 8.3 times.

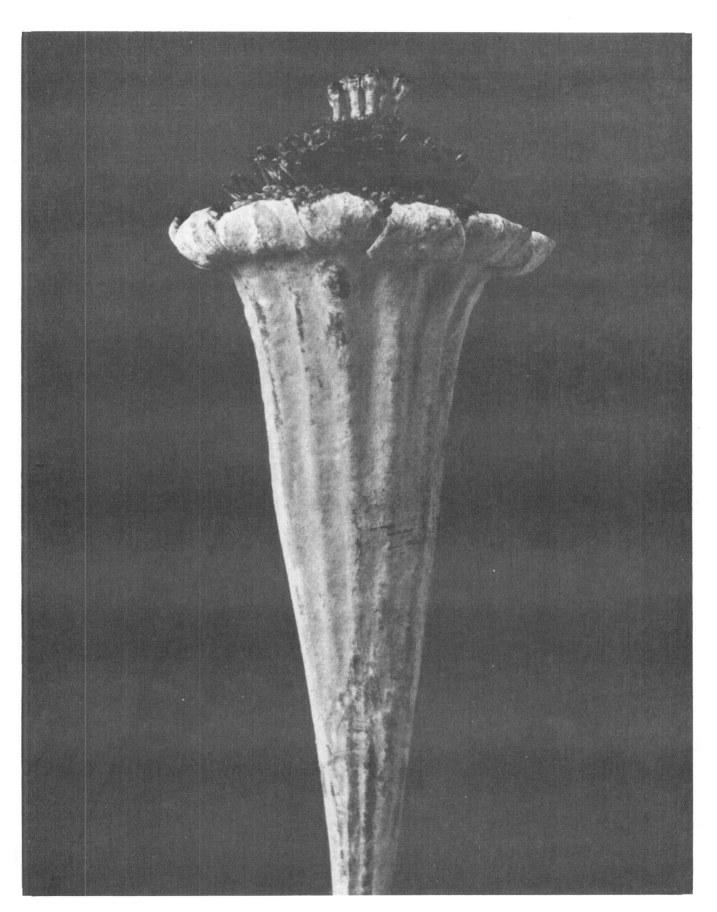

81. *Cotula turbinata*. Mayweed. Fruit, enlarged 12.45 times.

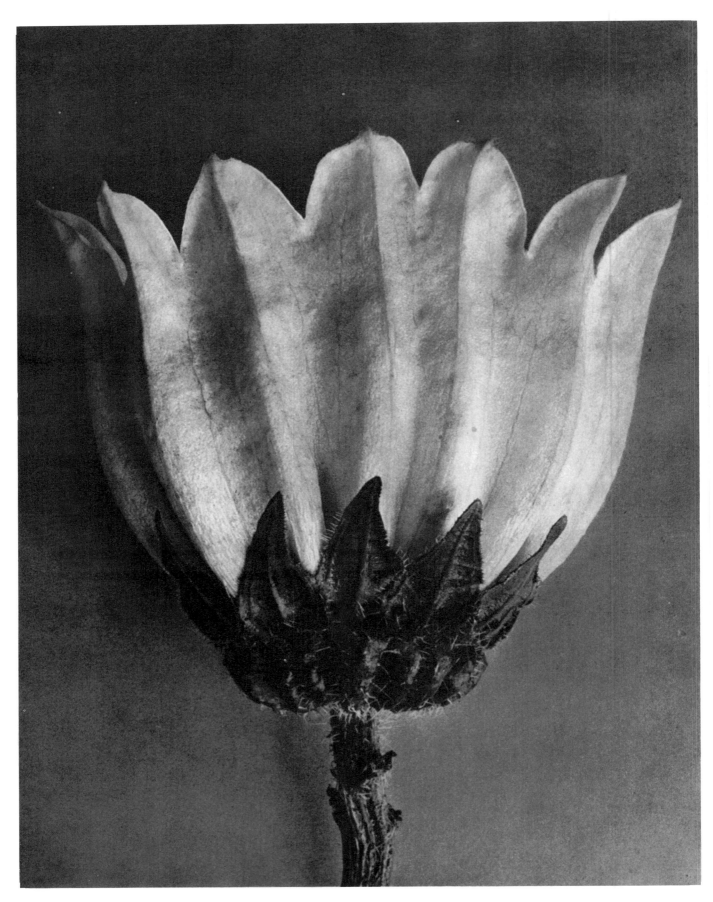

82. *Campanula medium*. Canterbury Bell. Enlarged 4.15 times.

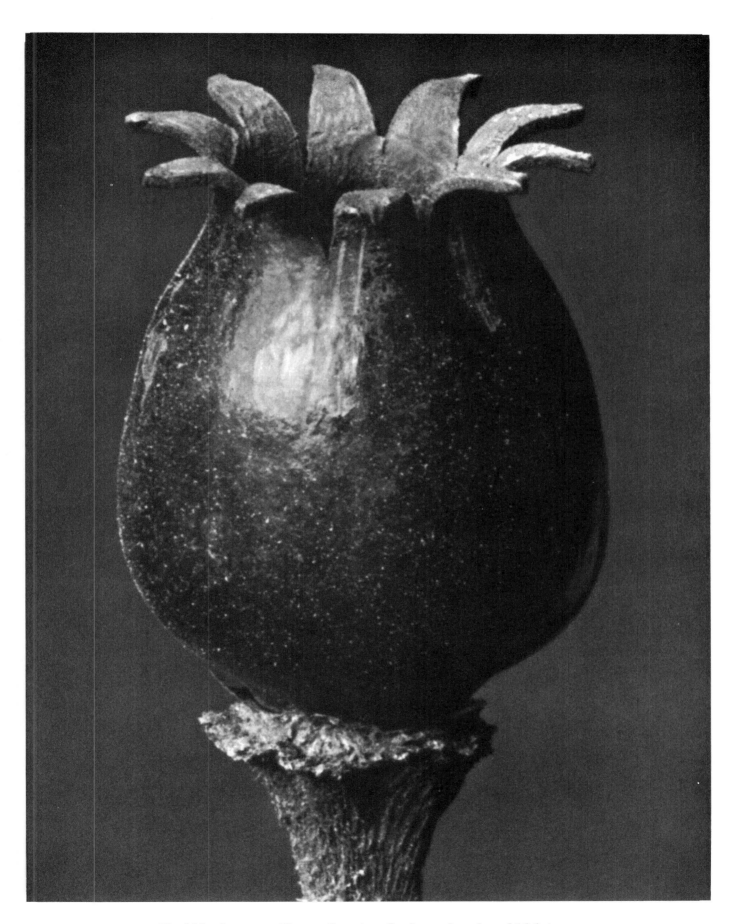

83. *Melandryum noctiflorum*. Campion. Seed capsule, enlarged 16.6 times.

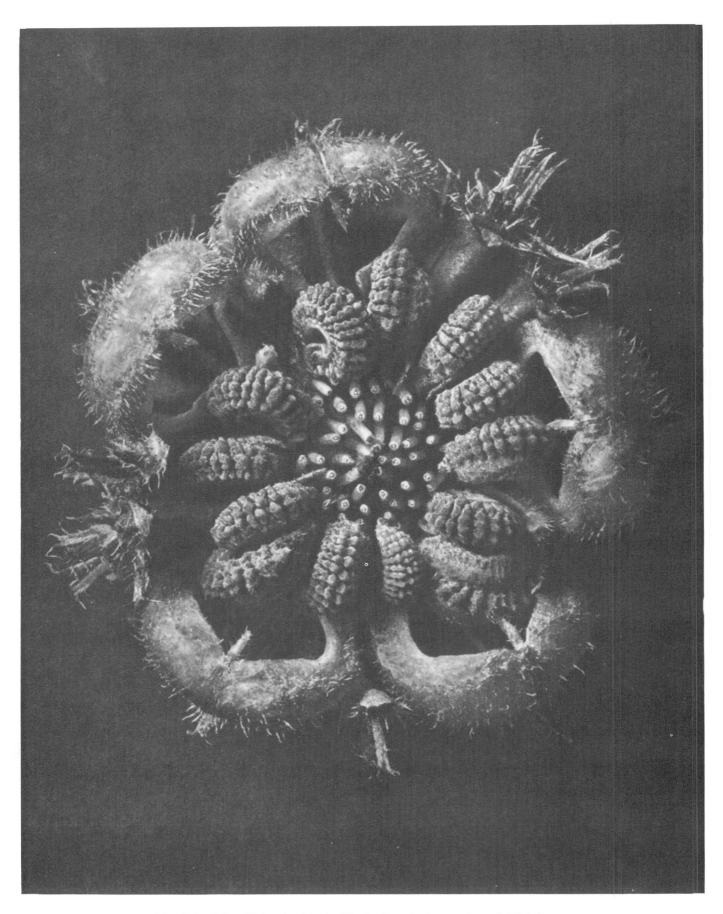

84. *Calendula officinalis*. Marigold. Seed capitulum, enlarged 4.98 times.

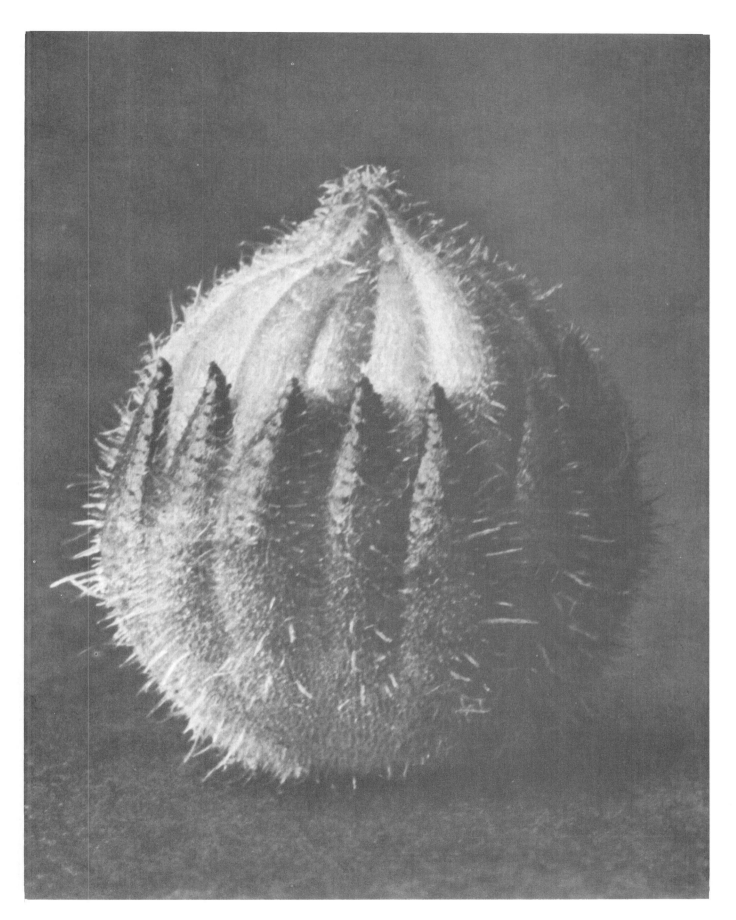

85. *Sempervivum tectorum*. Houseleek. Flower-bud, enlarged 24.9 times.

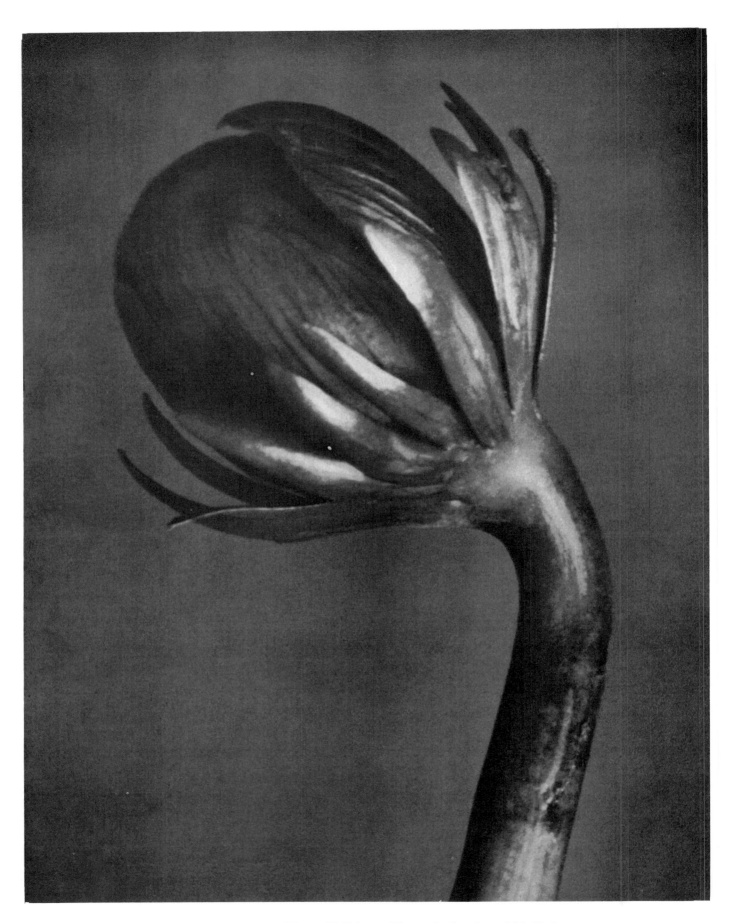

86. *Eranthis hiemalis*. Winter Hellebore. Flower-bud, enlarged 12.45 times.

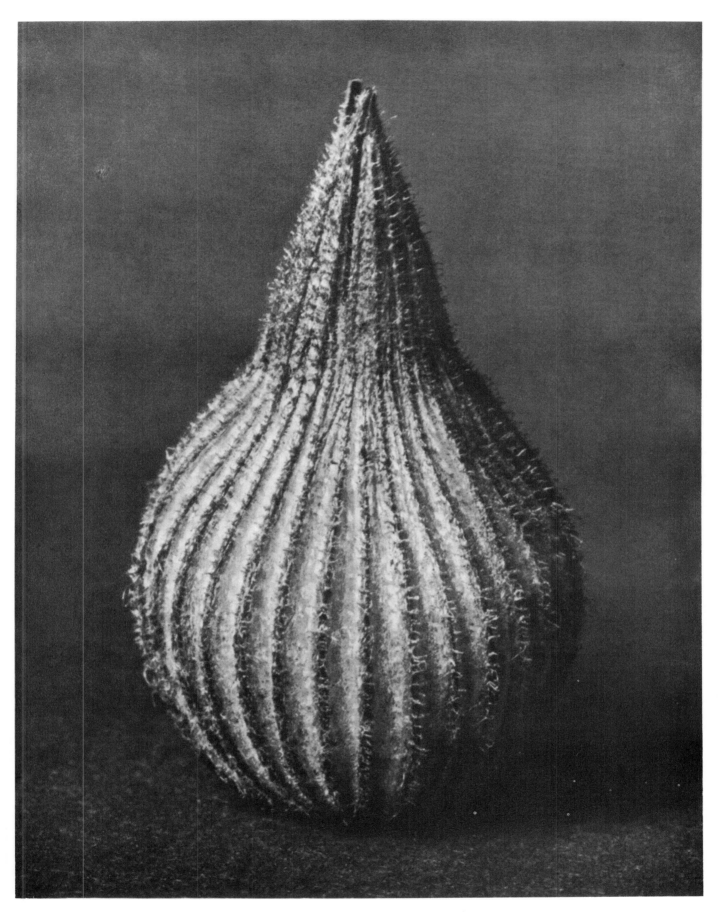

87. *Silene conica*. Striated Silene. Seed capsule, enlarged 16.6 times.

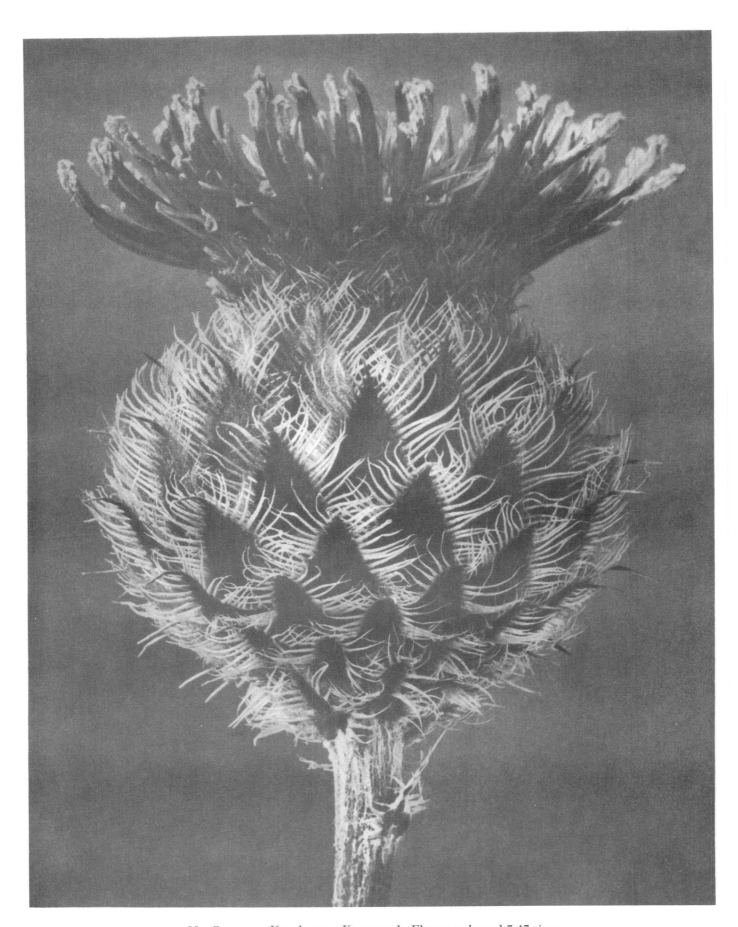

88. *Centaurea Kotschyana*. Knapweed. Flower, enlarged 7.47 times.

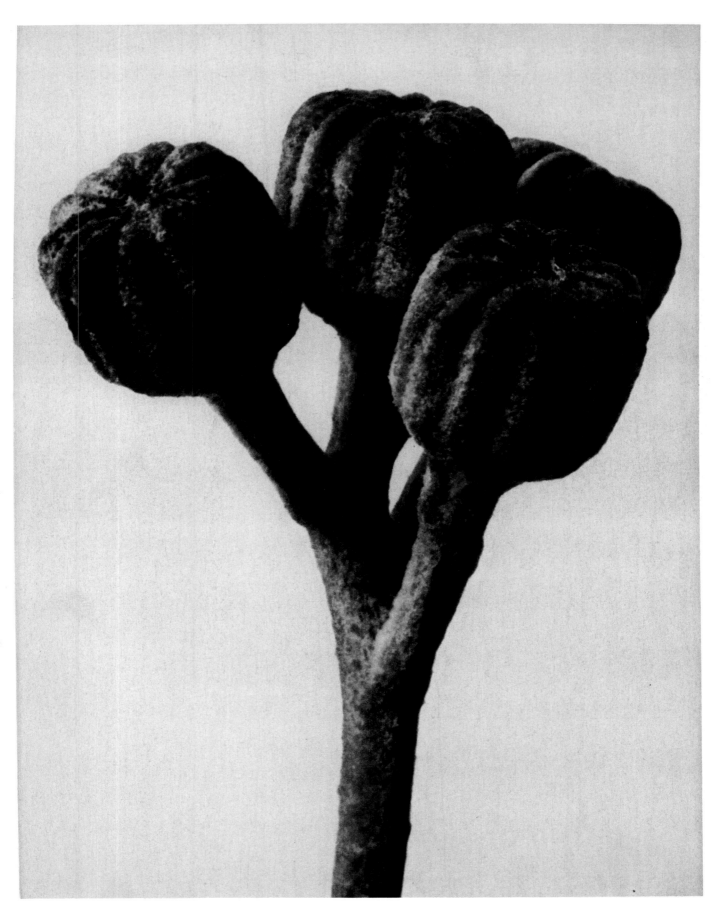

89. *Senecio cinneraria*. Dusty Miller. Flower-bud, enlarged 8.3 times.

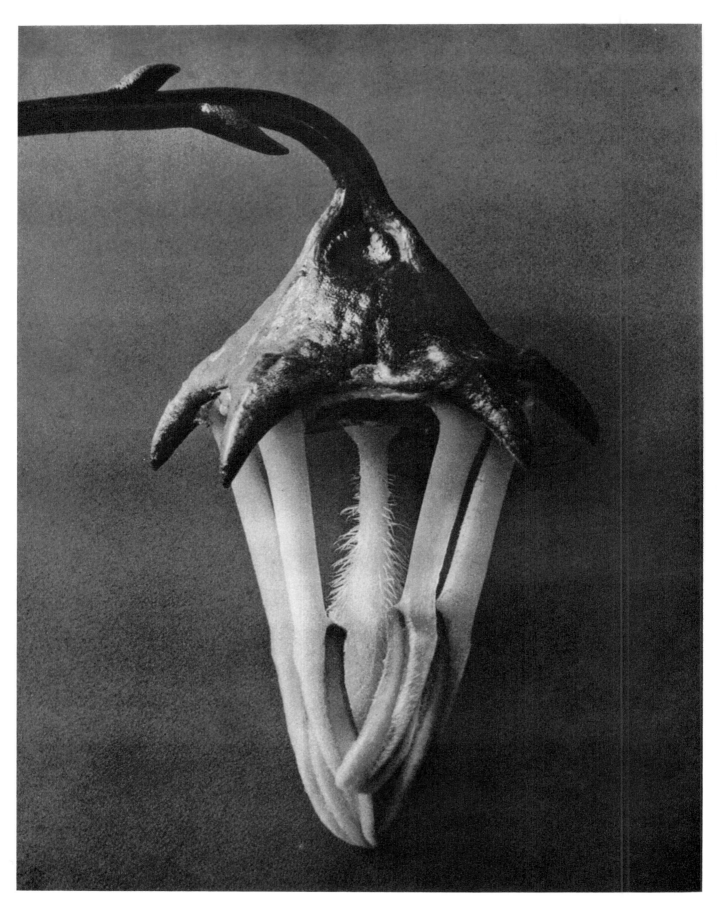

90. *Campanula Vidalii*. Campanula (petals removed). Enlarged 8.3 times.

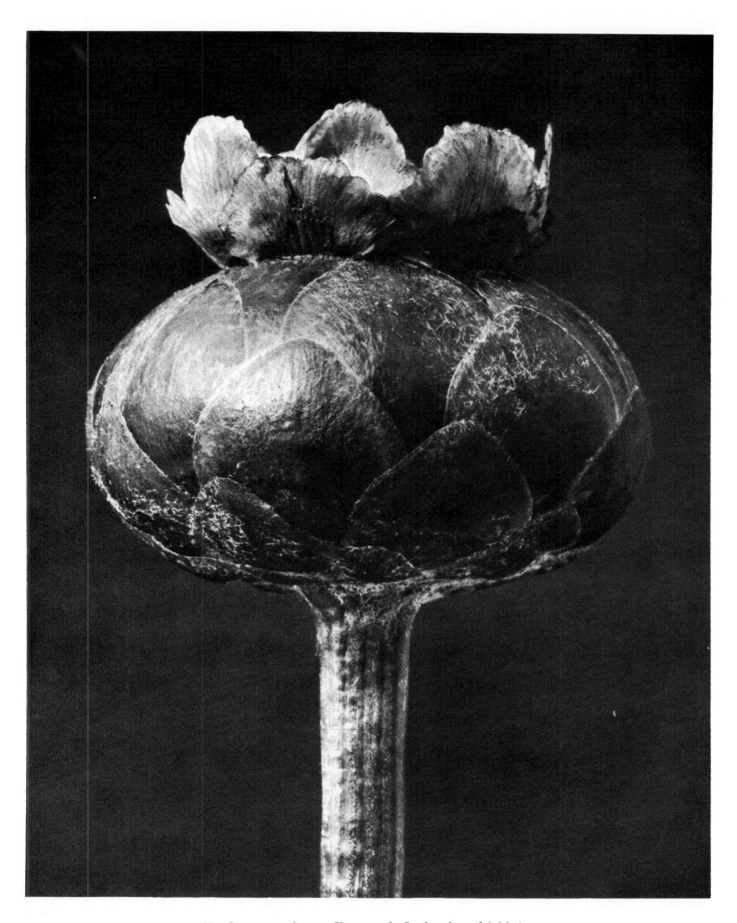

91. *Centaurea odorata.* Knapweed. Seed, enlarged 9.96 times.

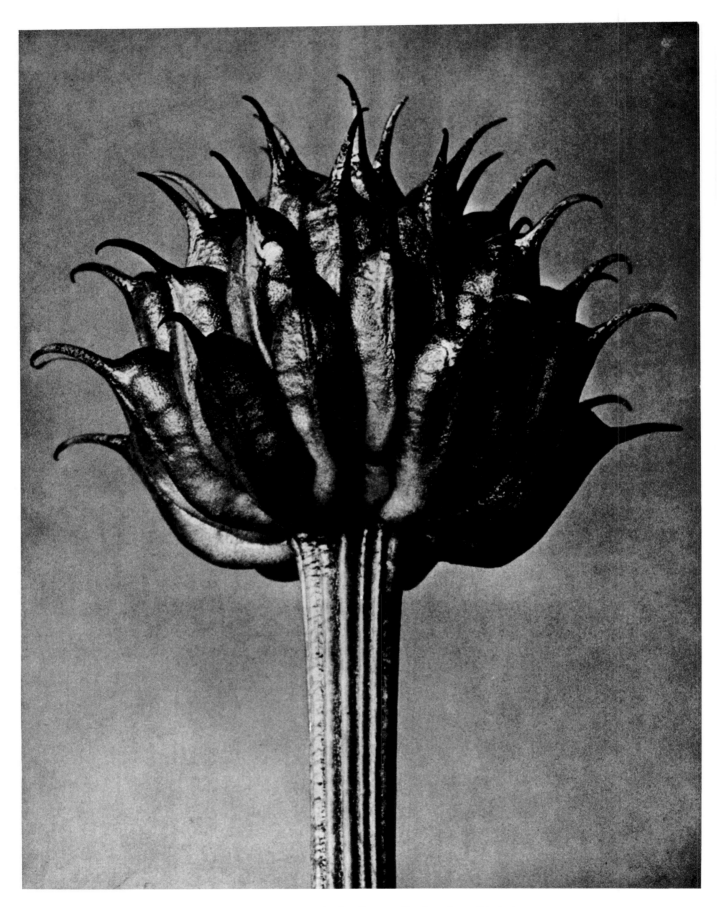

92. *Trollius Ledebourii*. Globe Flower. Seed, enlarged 8.3 times.

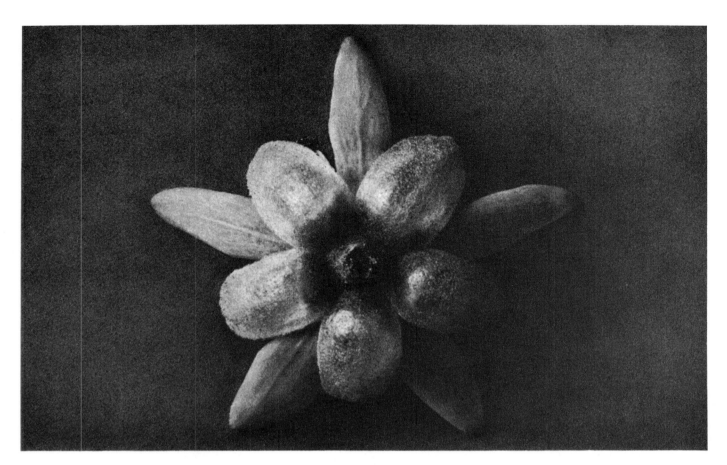

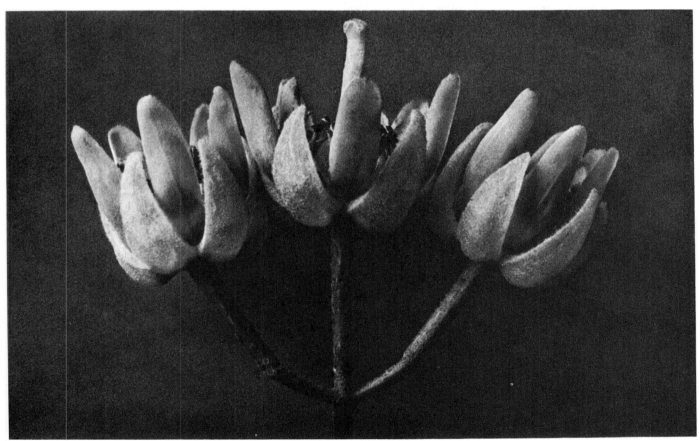

93. *Tilia americana*. Basswood. Blossom: a enlarged 7.47 times, b 4.98 times.

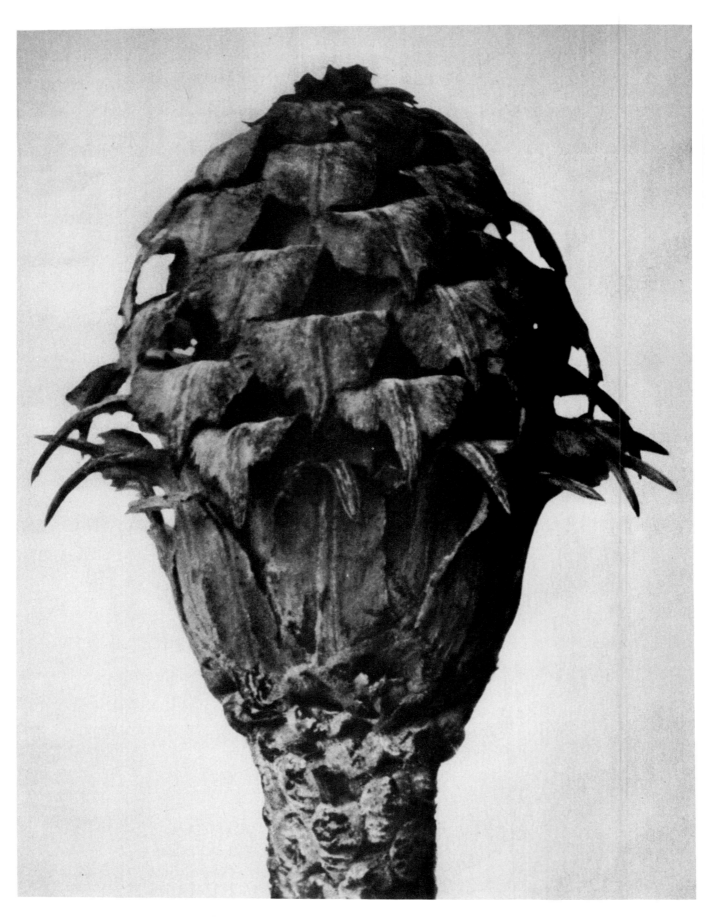

94. *Larix decidua*. Larch. Female catkin, enlarged 16.6 times.

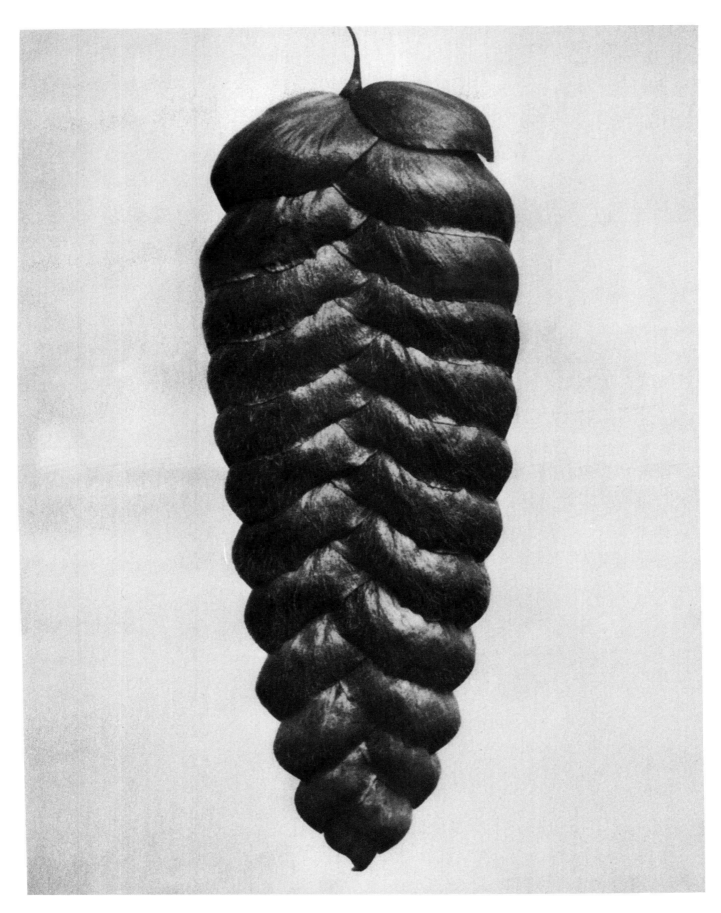

95. *Briza maxima*. Pearl Grass. Spikelet, enlarged 12.45 times.

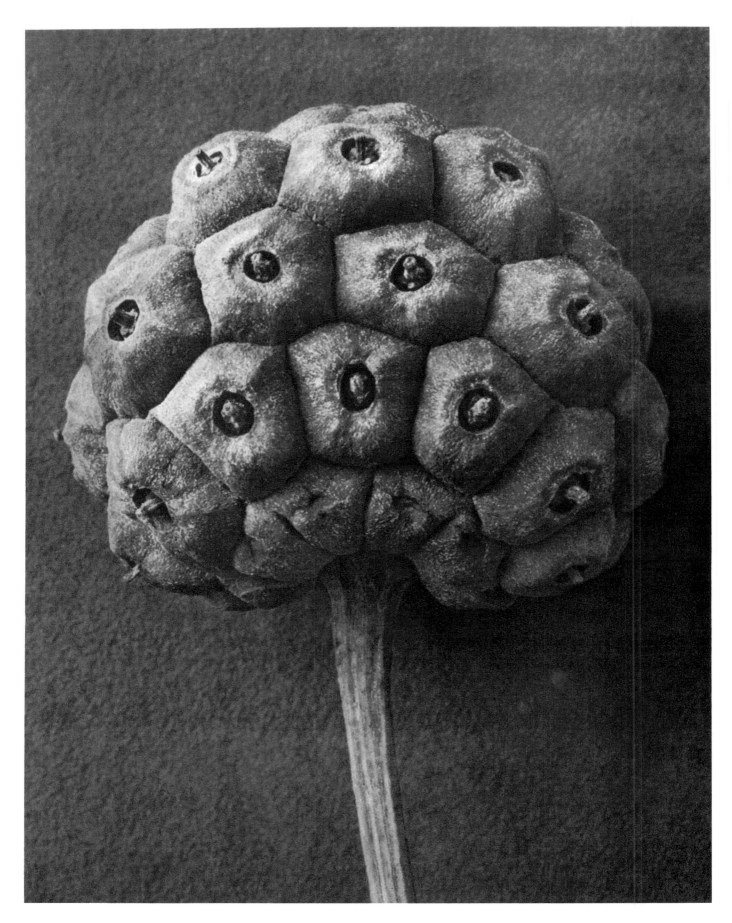

96. *Cornus kousa*. Dogwood. Fruit capitulum, enlarged 18.26 times.

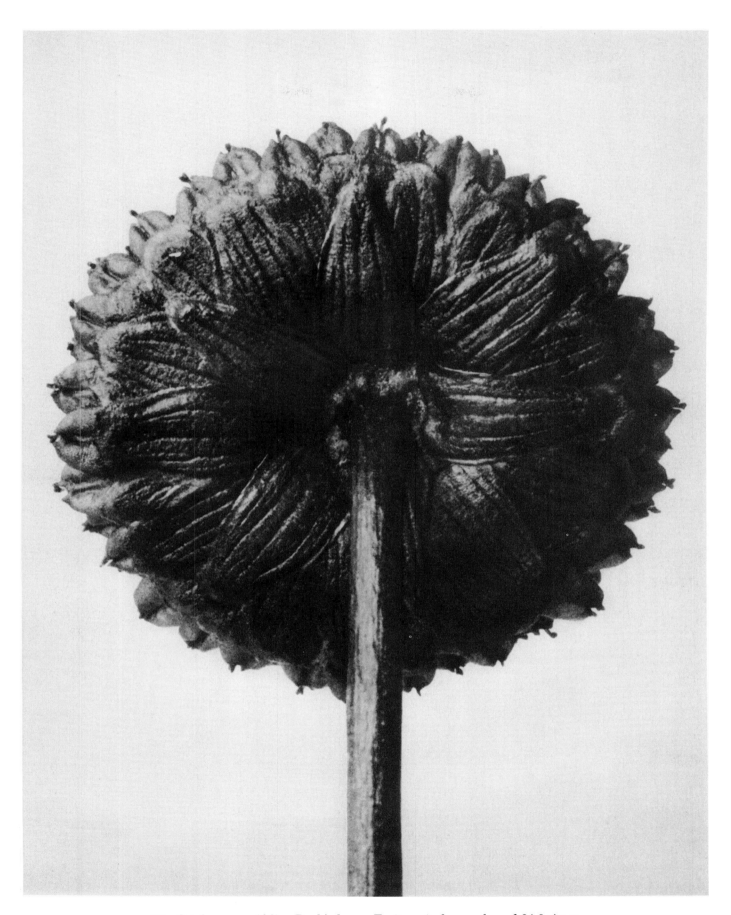

97. *Cotula coronopifolia*. Buck's-horn. Fruit capitulum, enlarged 24.9 times.

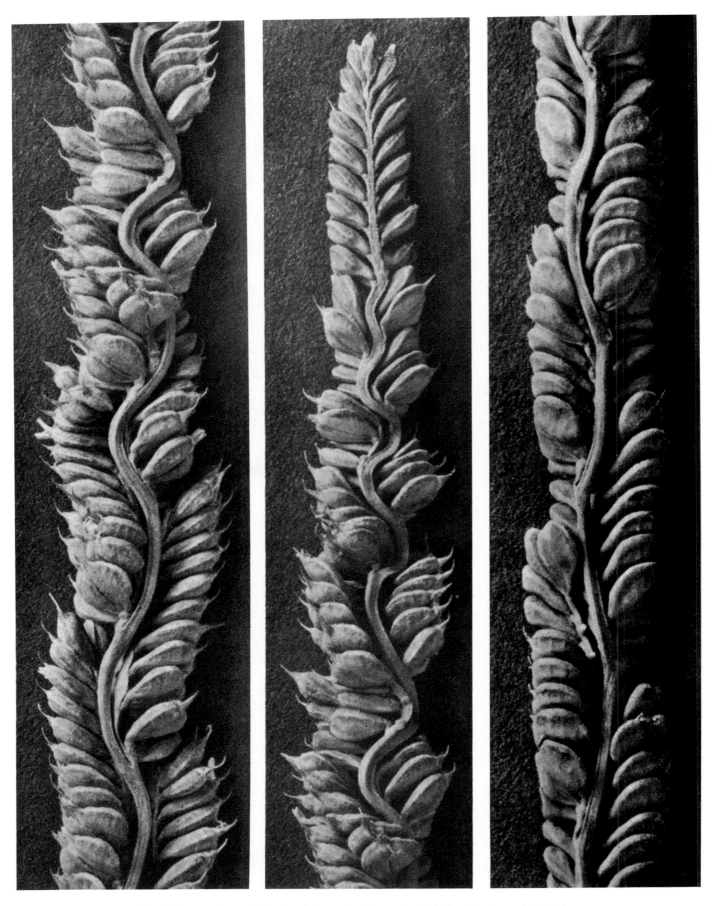

98. *Beckmannia eruciformis.* (From the Grass family.) Seed, enlarged 9.96 times.

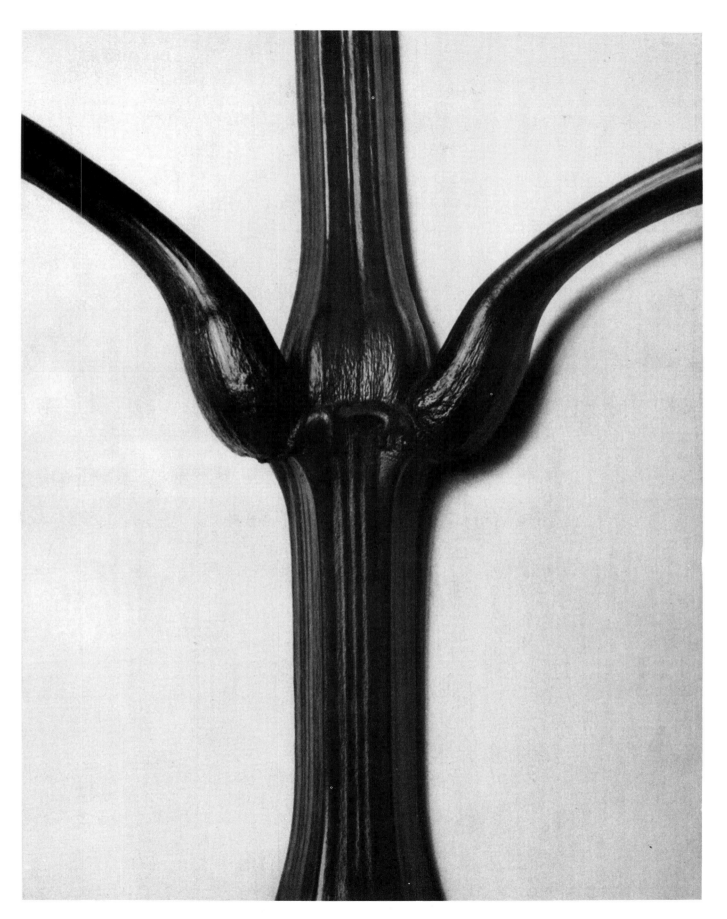

99. *Impatiens glanduligera*. Balsam. Branched stem, enlarged 1.66 times.

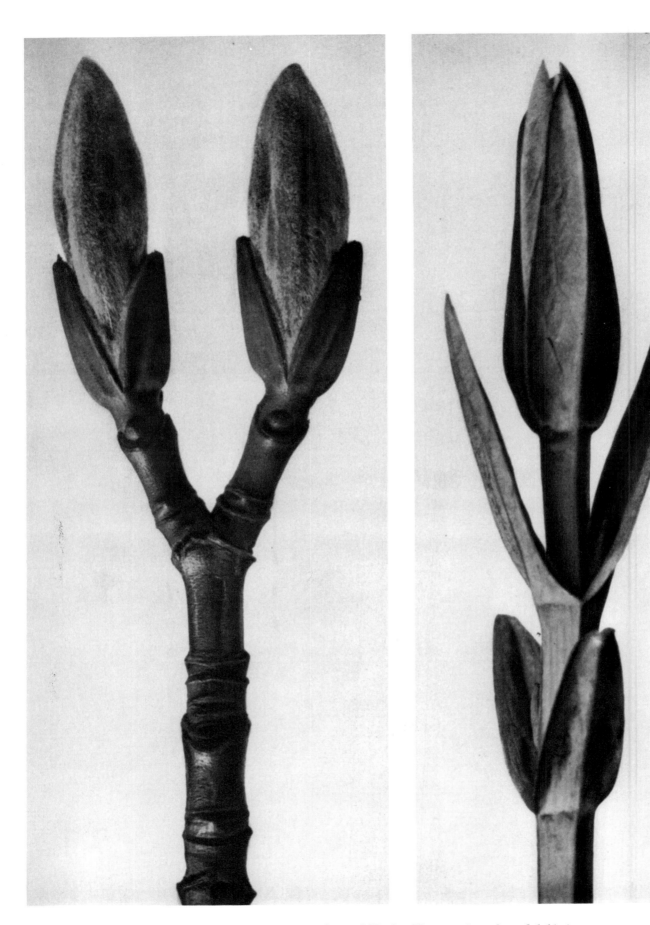

100. a *Acer pennsylvanicum*. Striped Maple. Young twig, enlarged 6.64 times.
b *Asclepias*. Swallow-wort. Young shoot, enlarged 4.15 times.

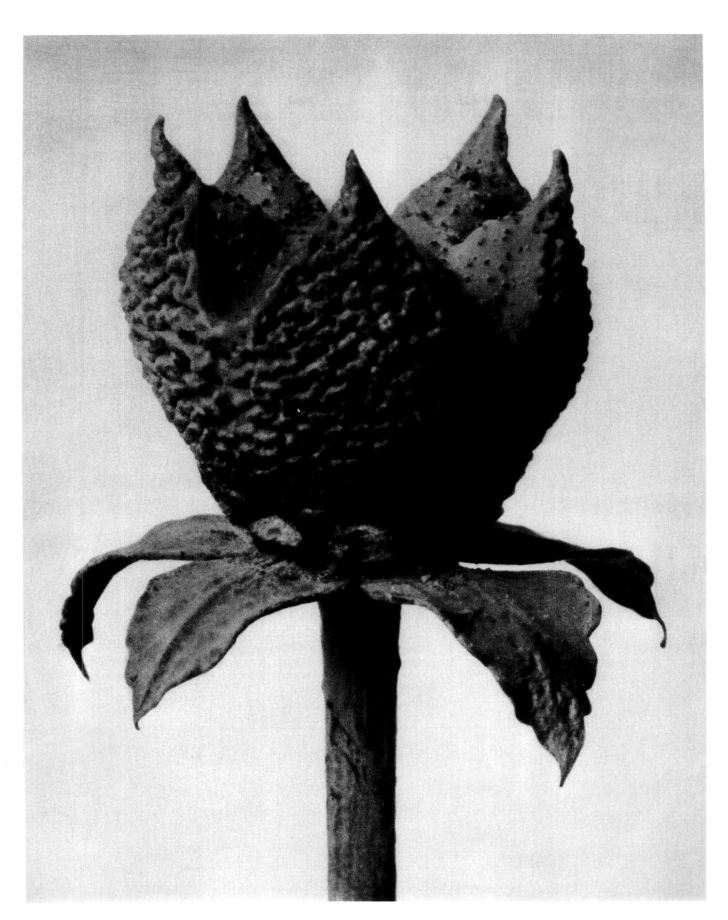

101. *Ruta graveolens*. Common Rue. Young fruit with calyx, enlarged 20.75 times.

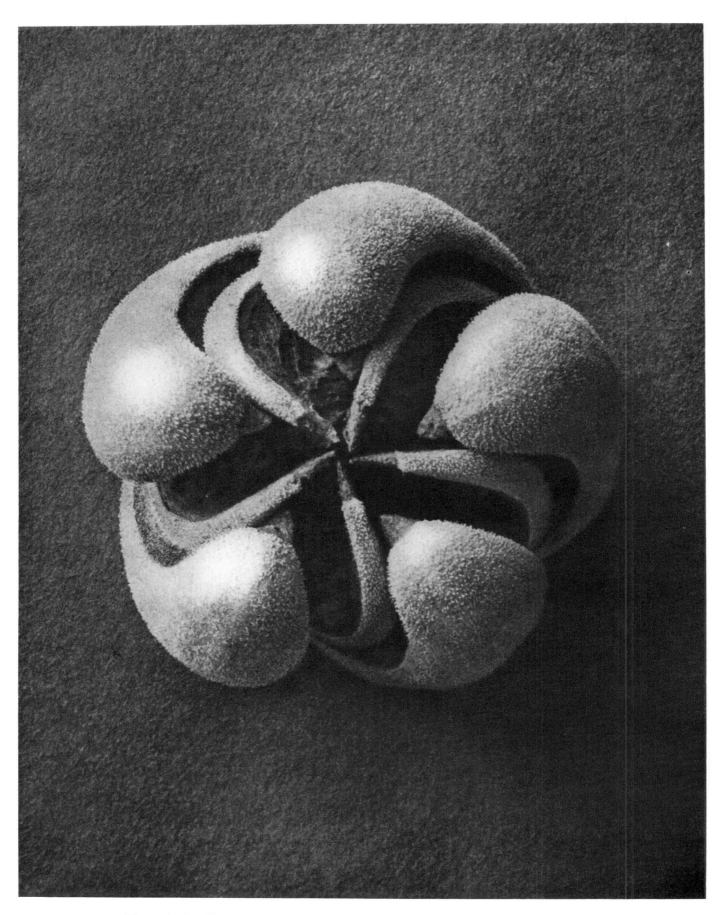

102. *Blumenbachia Hieronymi (Loasaceae)*. Nettle. Opened seed capsule, enlarged 6.64 times.

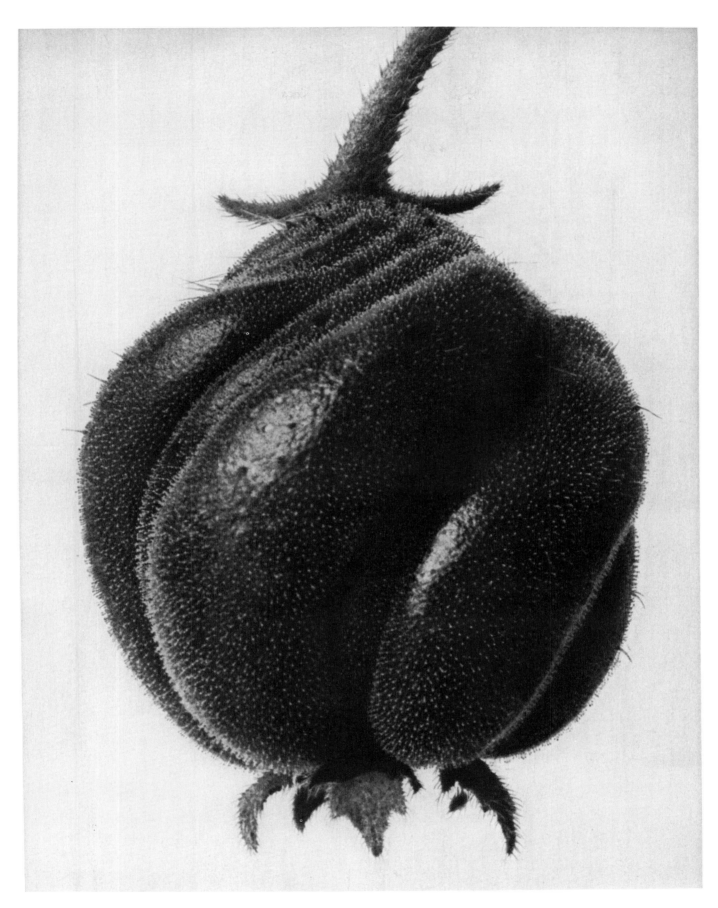

103. *Blumenbachia Hieronymi (Loasaceae)*. Nettle. Closed seed capsule, enlarged 14.94 times.

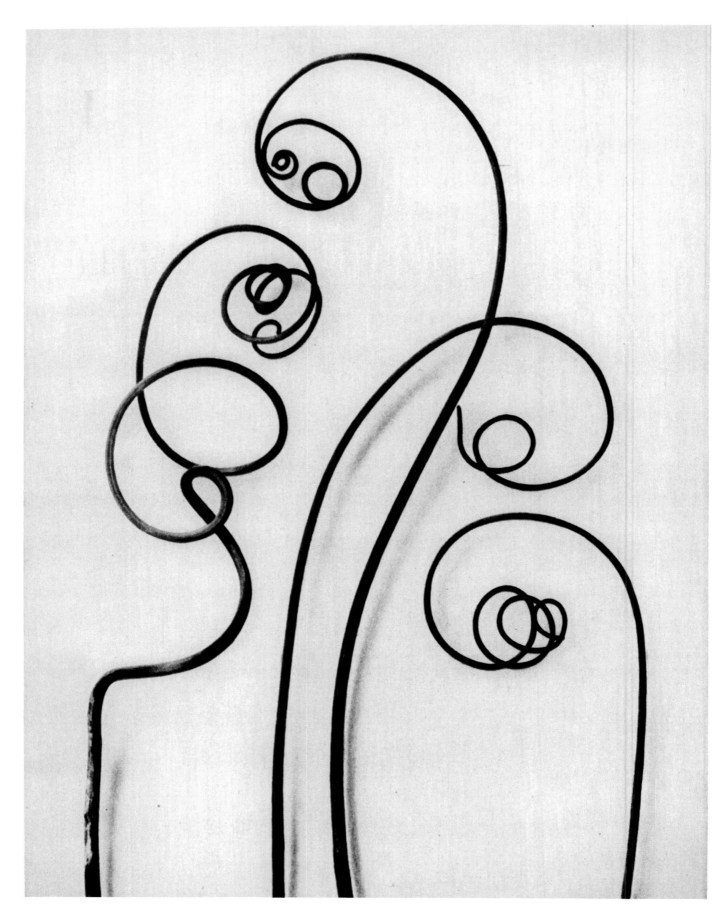

104. *Bryonia alba.* Bryony. Tendrils, enlarged 6.64 times.

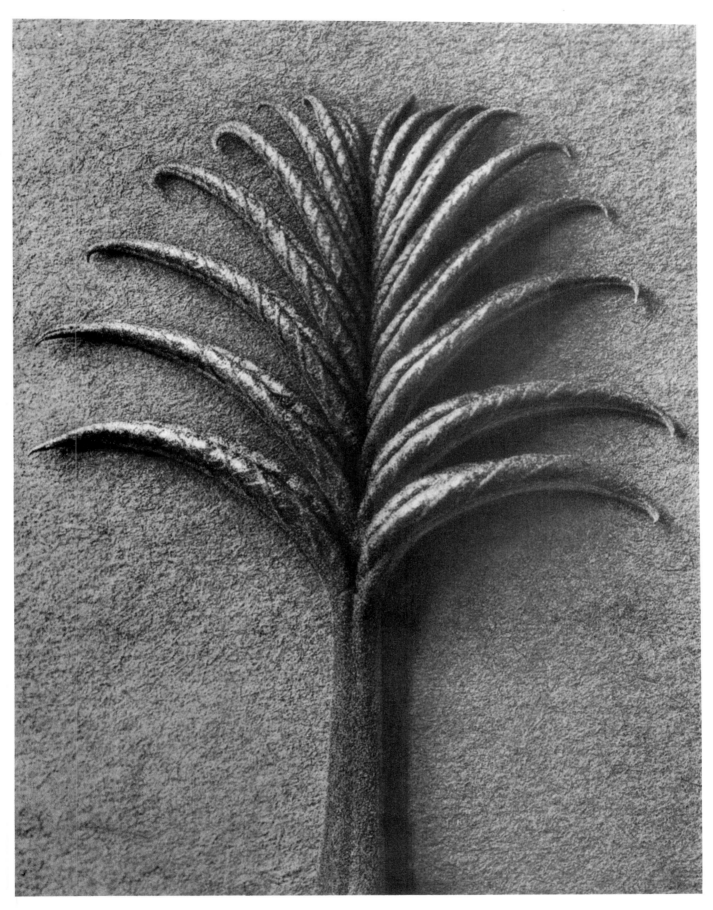

105. *Pterocarya fraxinifolia*. Ash-leaved Caucasian Walnut. Young leaf, enlarged 9.96 times.

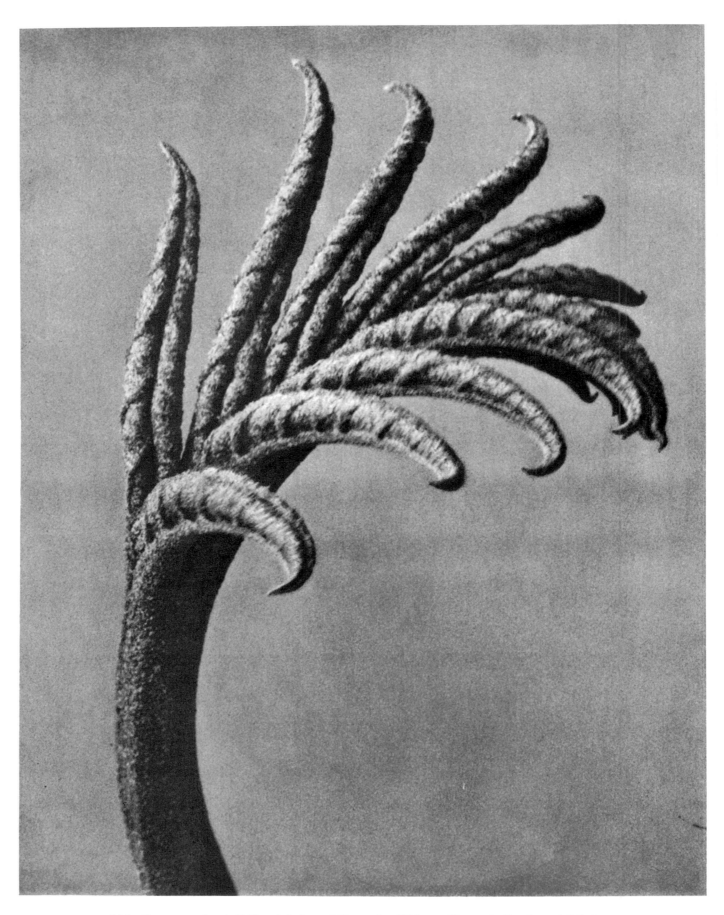

106. *Pterocarya fraxinifolia*. Ash-leaved Caucasian Walnut. Young leaf, enlarged 8.3 times.

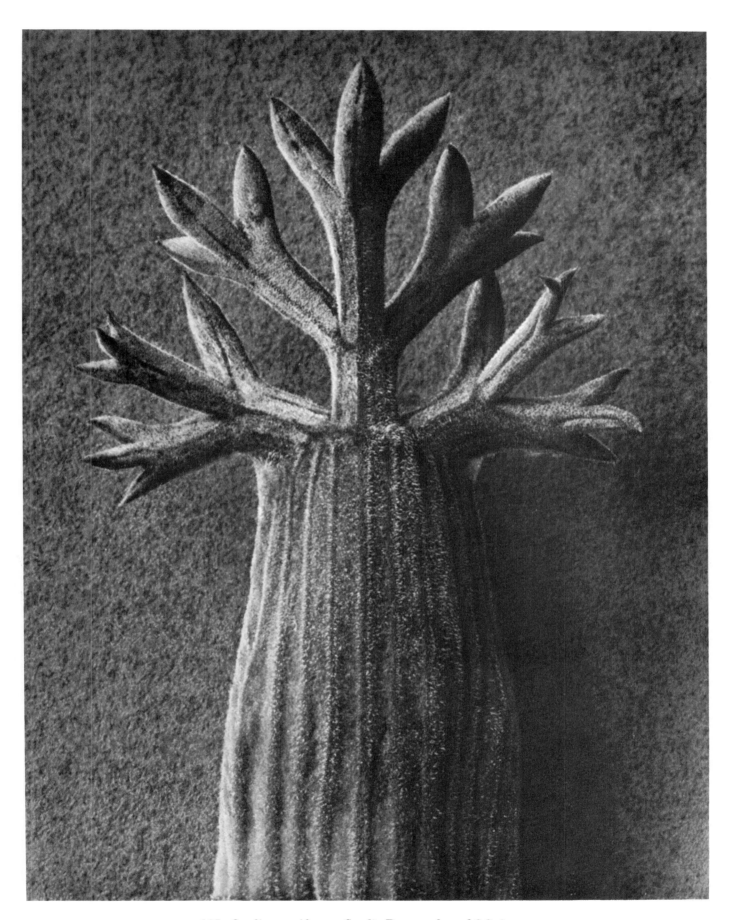

107. *Seseli gummiferum*. Seseli. Bract, enlarged 8.3 times.

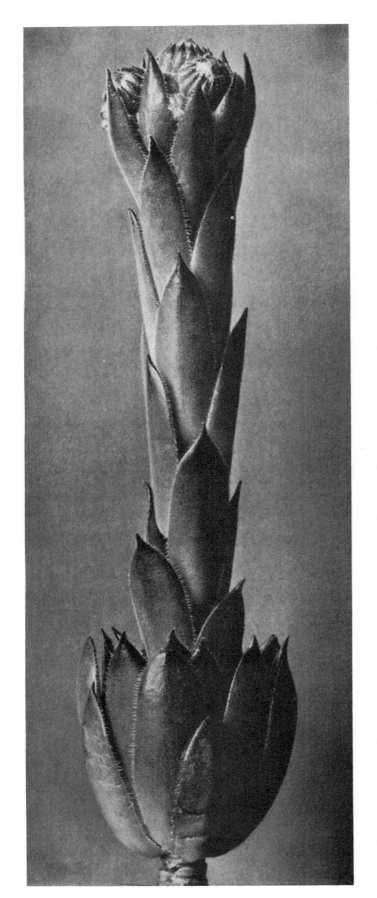 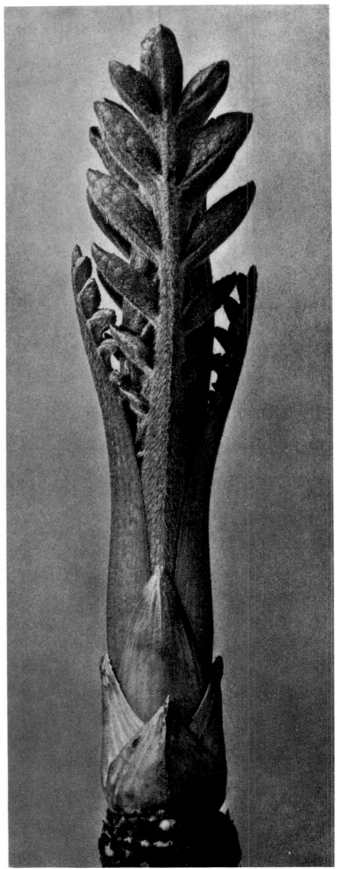

108. a *Sempervivum tectorum*. Houseleek. Enlarged 2.49 times.
b *Cephalaria dipsacoides*. Cephalaria. Young shoot, enlarged 4.15 times.

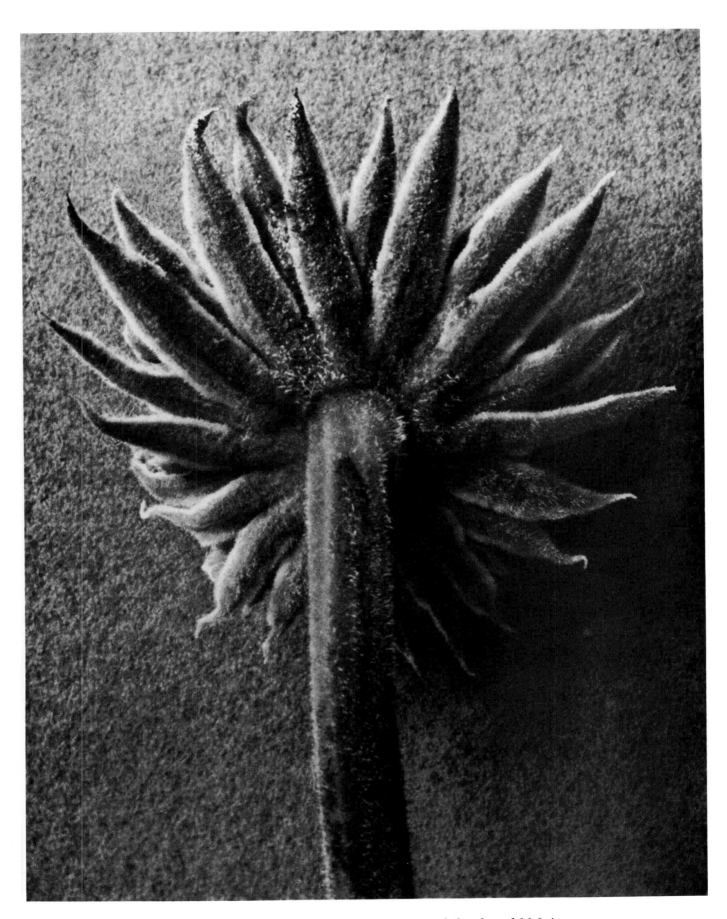

109. *Seseli gummiferum*. Seseli. Part of flower-umbel, enlarged 16.6 times.

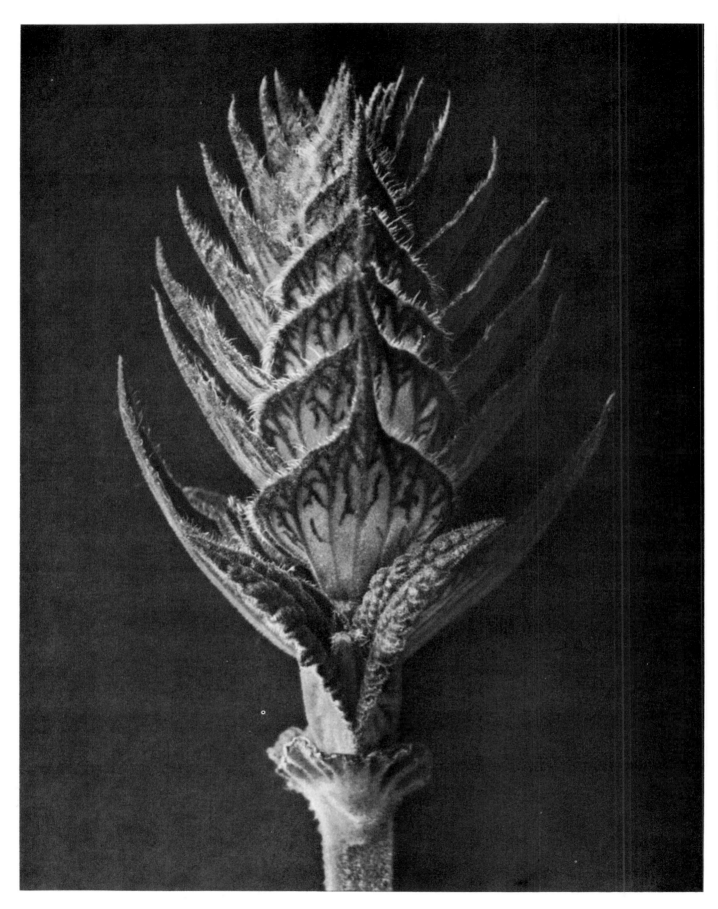

110. *Salvia pratensis.* Meadow Clary. Enlarged 8.3 times.

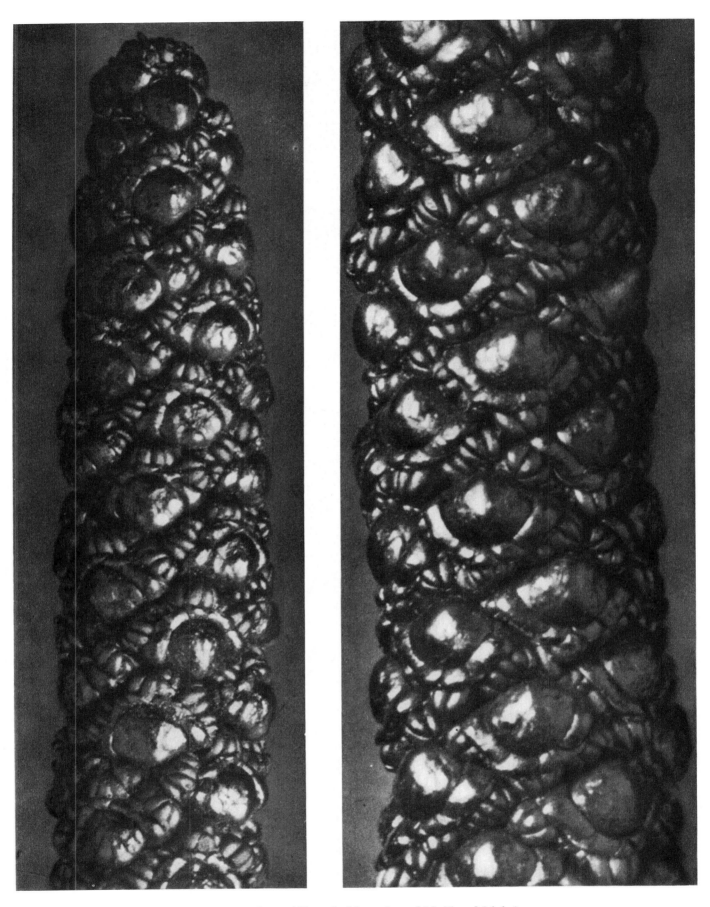

111. *Alnus cordata*. Alder. Catkin, enlarged 12.45 and 16.6 times.

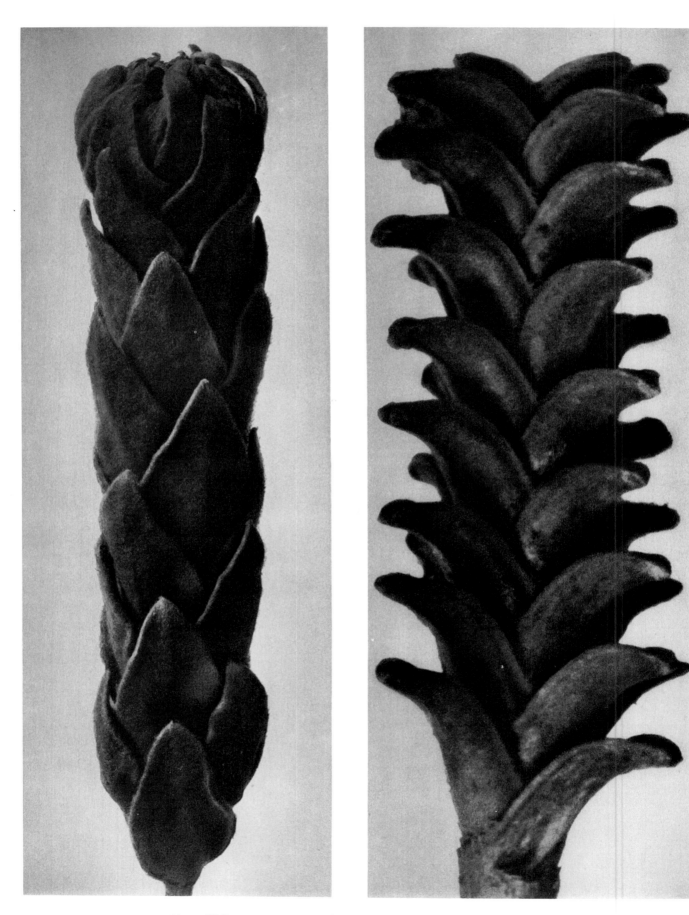

112. a *Helipterum eximium*. Immortelle Flower. Enlarged 1.66 times.
 b *Arenaria armeriastrum*. Sandwort. Enlarged 16.6 times.

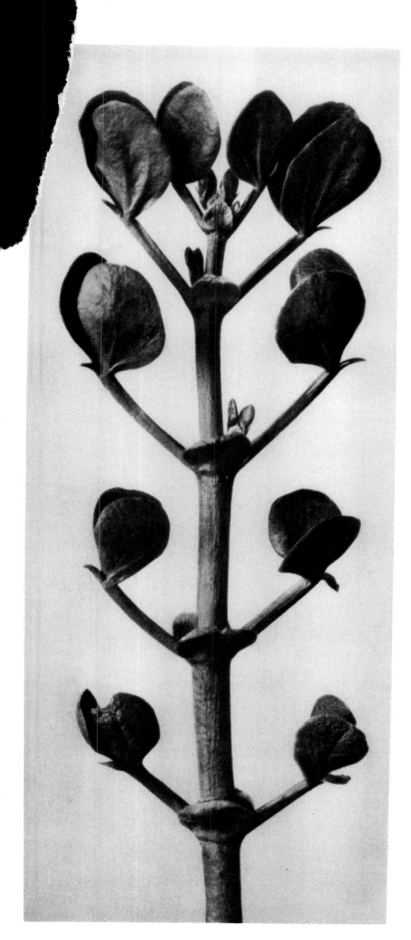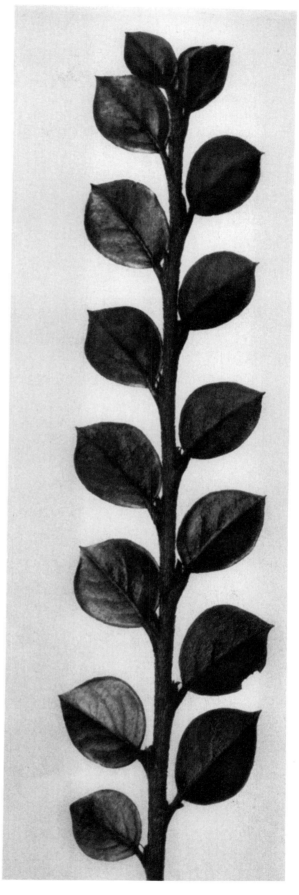

113. a *Zygophyllum fabago*. Common Cotoneaster. Enlarged 4.98 times.
b *Cotoneaster integerrima*. Syrian Bean-caper. Enlarged 6.64 times.

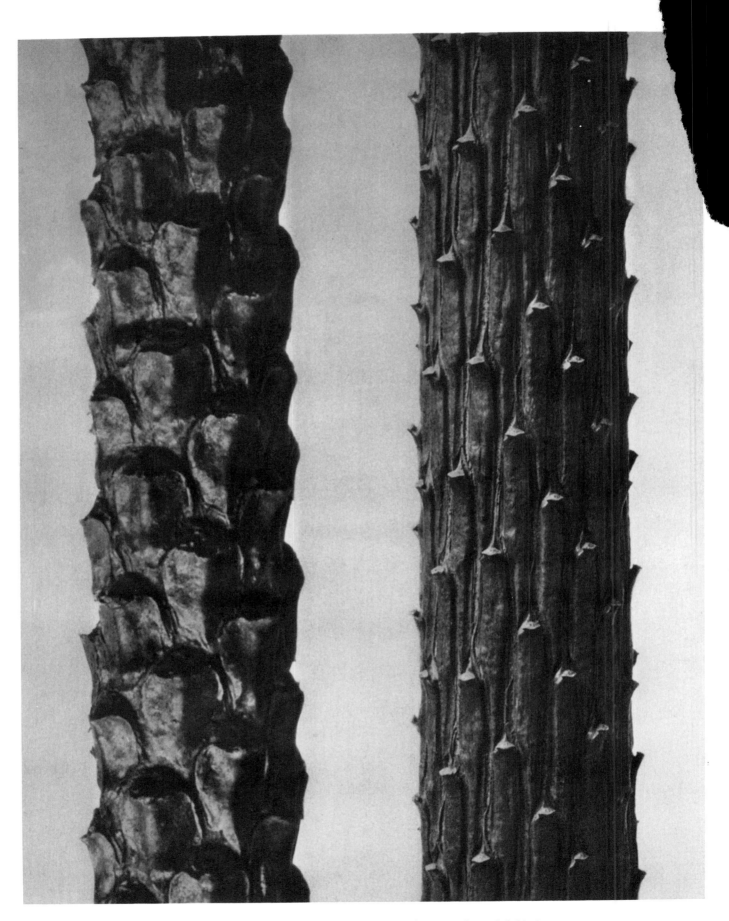

114. a *Pinus silvestris*. Scotch Pine. Piece of twig, enlarged 6.64 times.
 b *Picea excelsa*. Spruce. Piece of twig, enlarged 6.64 times.

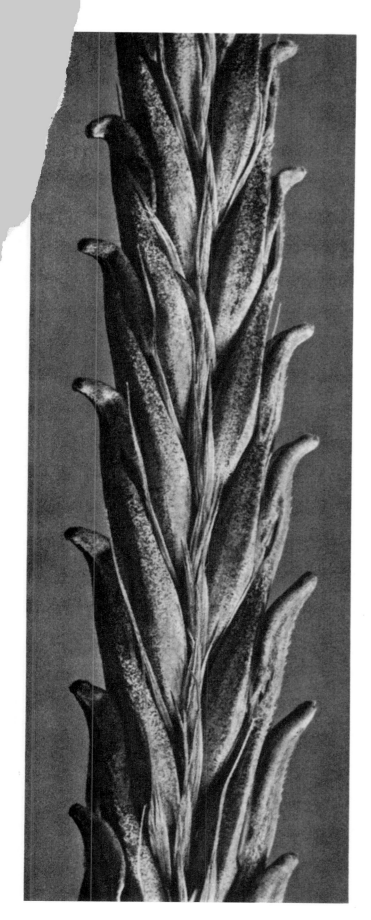 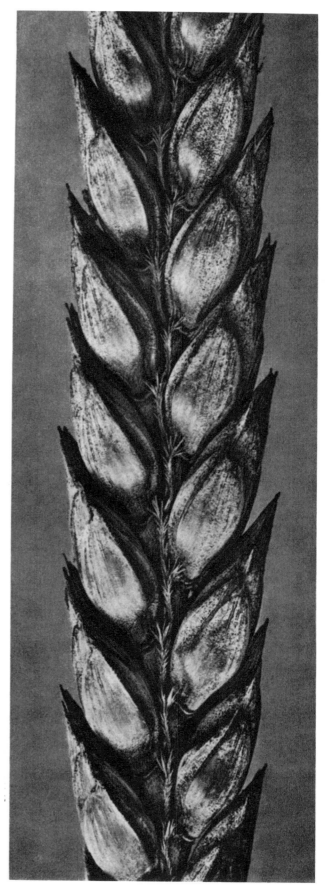

115. a *Triticum vulgare*. Wheat. Enlarged 4.98 times.
 b *Hordeum trifurcatum*. Barley. Enlarged 4.98 times.

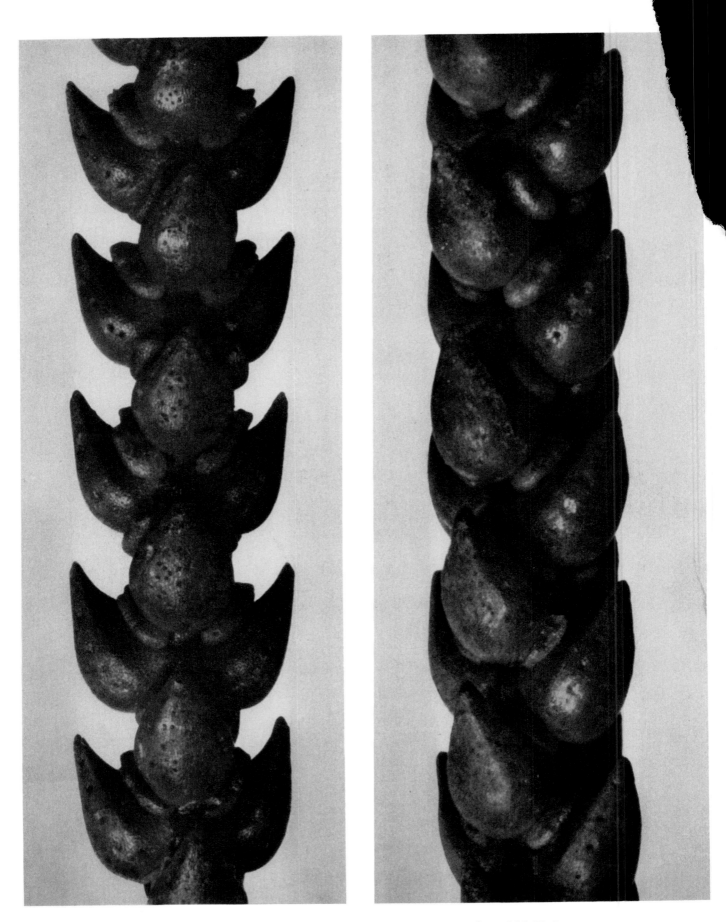

116. *Crassula lycopodioides*. Houseleek. Parts of stem, enlarged 11.62 times.

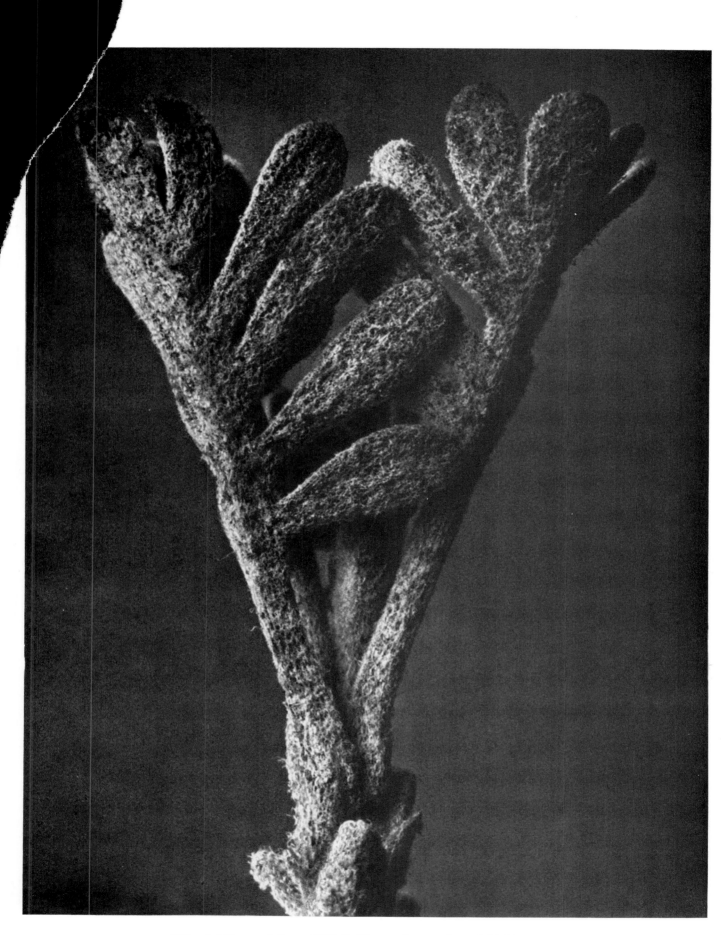

117. *Achillea umbellata.* Milfoil. Young shoot, enlarged 20.75 times.

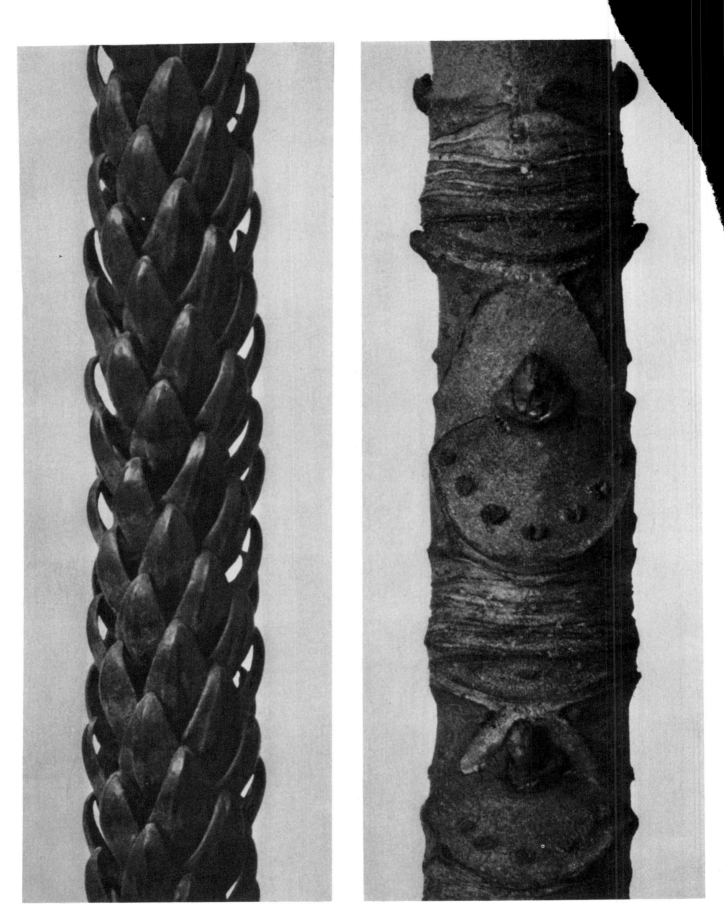

118. a *Araucaria*. Piece of twig, enlarged 4.96 times.
 b *Aesculus hippocastanum*. Horse-chestnut. Piece of twig, enlarged 8.3 times.

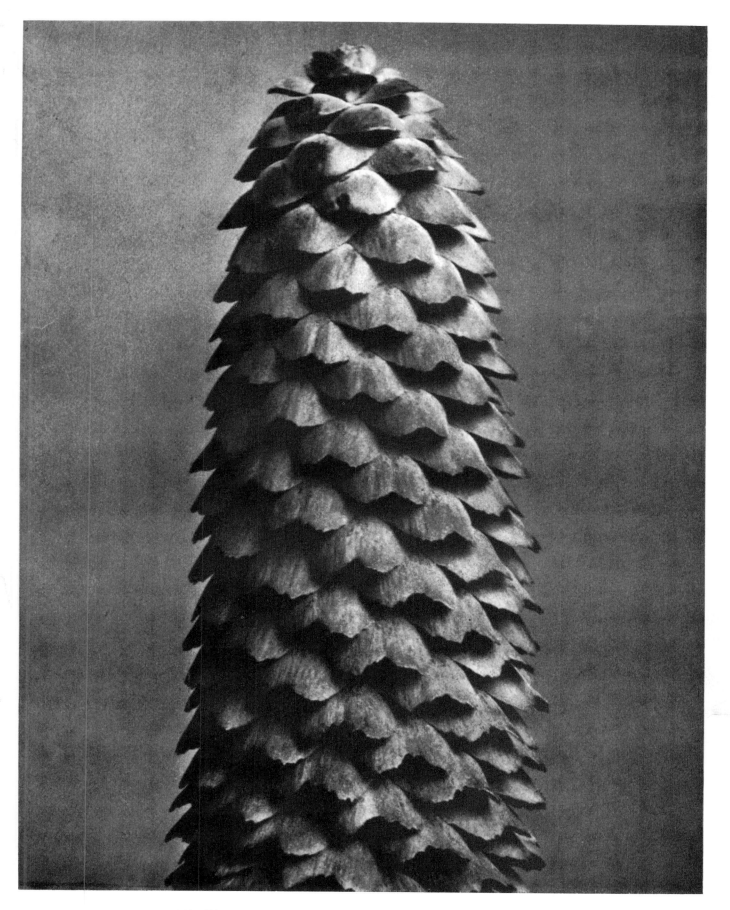

119. *Picea excelsa.* Spruce. Female catkin, enlarged 11.62 times.

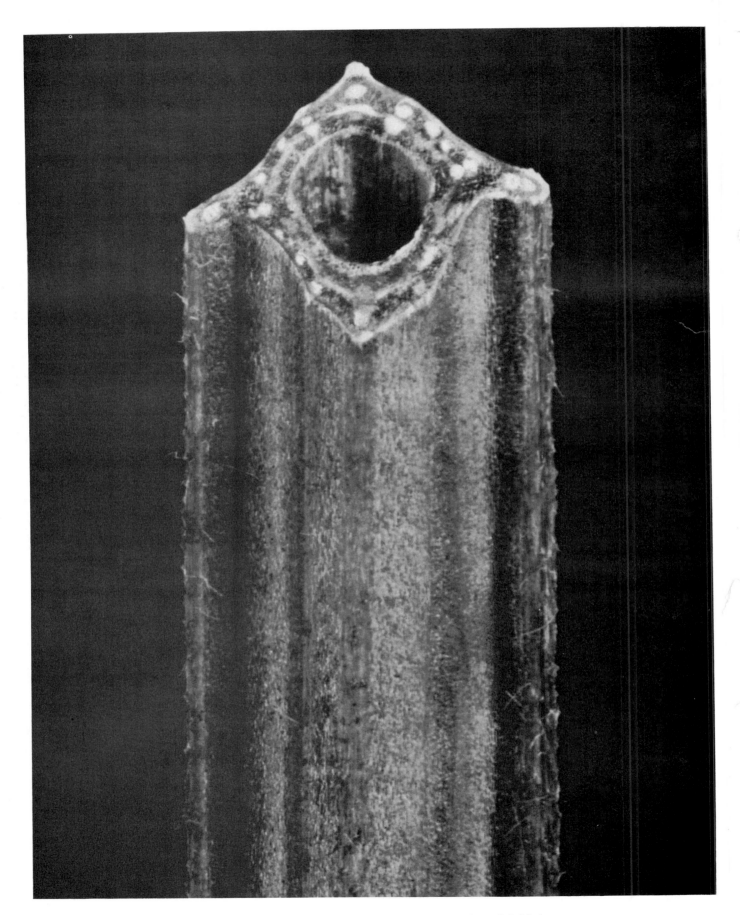

120. *Vicia Faba.* Broad Bean. Section of stem, enlarged 9.96 times.